IMAGES
of America

EDGARTOWN

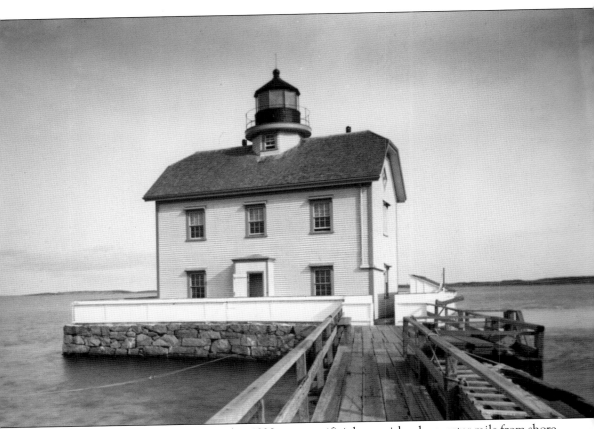

GATEWAY TO EDGARTOWN. Erected in 1828 on an artificial stone island a quarter-mile from shore, the first Edgartown Lighthouse marked the transition between the broad, funnel-shaped outer harbor and the narrow channel leading to the sheltered inner harbor. To the sailors who passed it—outward bound or returning from the sea—it symbolized home. (Courtesy of the Martha's Vineyard Museum.)

ON THE COVER: HOME FROM THE SEA. Dressed for fishing in old clothes and rubber boots, two men pull a skiff ashore in Edgartown's inner harbor just after 1900. Behind them, on the bluffs of Tower Hill, the homes of summer visitors look down on a harbor filled with catboats, sloops, and other small craft. (Courtesy of the Martha's Vineyard Museum.)

IMAGES
of America

EDGARTOWN

A. Bowdoin Van Riper
Martha's Vineyard Museum

ARCADIA
PUBLISHING

Published by Arcadia Publishing
Charleston, South Carolina

Printed in the United States of America

Library of Congress Control Number: 2017956369

For all general information, please contact Arcadia Publishing:
Telephone 843-853-2070
Fax 843-853-0044
E-mail sales@arcadiapublishing.com
For customer service and orders:
Toll-Free 1-888-313-2665

Visit us on the Internet at www.arcadiapublishing.com

To all those whose lives went unrecorded by the camera's gaze.

CONTENTS

Acknowledgments 6

Introduction 7

1. The Shire Town: 1642–1820 9

2. The World the Whalemen Made: 1820–1870 15

3. An Uncertain Future: 1870–1895 29

4. Building a Summer Resort: 1890–1920 41

5. A Changing Waterfront: 1900–1940 71

6. Learning to be Modern: 1920–1945 83

7. Welcoming the World: 1946–1975 103

Bibliography 126

About the Martha's Vineyard Museum 127

ACKNOWLEDGMENTS

Writing is profoundly solitary, but creating a book is intensely collaborative. It has been my pleasure and my privilege, in creating this particular book, to have the best collaborators any writer could ask for.

Thanks, therefore, to Arcadia Publishing acquisitions editor Erin Vosgien for proposing the project and to editor Liz Gurley for guiding me through the making of a book that has more images than all my previous books combined. Thanks to all those who work behind the curtain at Arcadia: you make Edgartown—and me—look good.

Thanks, too, to the staff and volunteers of the Martha's Vineyard Museum for believing so intensely in the greater project—connecting people with the history and culture of our island—of which this book is one small part, and for making it so much fun to come to work every day.

Thanks especially to Phil Wallis for making his first question "Do you want to?", to Bonnie Stacy for the insights that come with having been there and done that, to Anna Barber and Teresa Kruszewski for gracefully rescuing me from unexpected complications, and to Liz Trotter for cheerfully putting up with my odd requests ("herring fishing, with horses") and imperfect directions ("I think it's in a blue binder") and for being a much-relied-upon second opinion.

Thanks, finally, to Cindy Miller for keeping me sane . . . and all the other reasons, too.

All images in this book, unless otherwise noted, are from the collections of the Martha's Vineyard Museum.

INTRODUCTION

The island of Martha's Vineyard lies off the southern coast of Cape Cod, Massachusetts: 100 square miles of boulder-studded gravel, sand, and clay bulldozed into a rough triangle by the advancing glaciers of the last great ice age. It was not, at first, an island, just a nameless high spot on the broad, sandy plain that, in those days when the expanding ice cap temporarily lowered global sea levels, stretched southward for miles across what is now the continental shelf.

In time the climate warmed, the glaciers gave up their waters, and the seas reclaimed what had been theirs. The Wampanoag, who began coming when they could walk there dry-shod and stayed after the waters rose, cutting off the mainland, named it for what it was: Noepe, or "dry land amid waters." The Europeans—who arrived some 10,000 years later, in their tall ships and hammered-steel breastplates—named the place with a different kind of practicality in mind. The Luisa after whom Giovanni de Verrazano christened the island as he passed by it in 1524 (before turning for Newport in the face of a northeasterly gale) was the mother of his patron, the king of France. Bartholomew Gosnold's Martha, whose name it carries today, was likely his mother-in-law, who had helped to fund his 1602 expedition to the New World.

The sheltered waters on whose shores the first Europeans settled—two broad bays joined, like the glass bulbs of an hourglass, by a slender, twisting channel—were originally named with a directness the Wampanoag might have appreciated: Great Harbour. The same name attached to the village that, in the 1640s, was coalescing along its shores.

A generation later, however, the urge to honor distant patrons raised its head again. In September 1667, Anne Hyde, wife of James, Duke of York (later King James II of England), bore him a son. The boy was christened Edgar, Duke of Cambridge, and the newborn village was rechristened in his honor: Edgartown. The boy died—felled by disease before his fourth birthday—but the village name lived on. In all the English-speaking world, it is said, there is only one Edgartown—a fitting distinction for a town with an unusually complex, multifaceted identity.

Edgartown has long been Martha's Vineyard's seat of regional government, its foremost center of learning, and its most religiously diverse community. Two public schools and two private academies once operated within a few blocks of each other on what is now aptly named School Street. The towers of six new churches representing five separate denominations rose against its skyline between the mid-1820s and the mid-1920s. The island's antislavery society, its historical society, and its leading debating society (the Edgartown Lyceum) were all founded there; the Vineyard's chapter of the NAACP marched for the first time on its streets.

It has been at varying times in its 375-year history a port for inshore and offshore fishing vessels, a home base for whaling ships, a port of entry for merchant ships from across the world, and a destination for recreational sailors up and down the East Coast. Sheep pastured in its meadows, dairy cows stabled in its barns, and row crops harvested from its fields have helped to feed Vineyarders for centuries. Its ponds yielded eels and herring, oysters and scallops, for island and mainland fish markets alike.

Martha's Vineyard and manufacturing are—with good reason—rarely mentioned in the same sentence, and when they are, the focus is on West Tisbury with its woolen mill (now the Garden Club) or Chilmark with its brickworks (now an overgrown ruin). Edgartown rarely enters the discussion, but its track record of industrial enterprises is well over two centuries long. Thomas Cooke, whose home is preserved today by the Martha's Vineyard Museum, owned and operated a commercial salt works on the waterfront, where sunlight evaporated seawater left in broad, shallow wooden trays. Daniel Fisher, the wealthiest man of the whaling era, owned a hardtack bakery and a waterfront factory that turned spermaceti—a waxy substance from the heads of sperm whales—into premium-grade candles. Plants to produce everything from shoes and firearms to high-quality artificial pearls made from herring scales have, if only briefly, found a home there.

The Martha's Vineyard Railroad, the greatest (and most quixotic) of all the Vineyard's industrial enterprises, was conceived in Edgartown and funded by some of its leading citizens. It was, along with the sprawling Mattakeset Lodge hotel, the beginning of a decades-long campaign to establish Edgartown as a summer resort. The railroad and Mattakeset Lodge ultimately failed, but the transformation succeeded. Over the course of the late 19th and early 20th centuries, Edgartown reinvented itself as a summer-centered community of resort hotels, bathing beaches, and genteel vacation homes.

Edgartown, as summer vacation spot, welcomed the world to its shores and became, in the process, an unlikely cultural icon. It acted as the backdrop to Henry Beetle Hough's best-selling memoir *Country Editor*, became the stage for the political scandal that ended Sen. Edward Kennedy's hopes for the presidency, and transformed itself into the fictional resort of Amity, menaced by a killer shark in *Jaws*. A small seaside town thus became, seemingly overnight, world-famous.

Geography and language are idiosyncratic things, and so it is with Edgartown. Like many old New England place names, it is used for two distinct but intimately related entities: a township and its principal village.

Edgartown (the township) is bordered on three sides by fragile barrier beaches constantly remade by wind and waves, and on the fourth by pine-forested sandplains (comparatively) little-altered since they were formed by the retreating glaciers of 10,000 years ago. Until 1880, it included all of what is now Oak Bluffs. It still includes the sometime-island of Chappaquiddick: a land apart, even when Norton Point—the strip of beach that divides Katama Bay from the sea—remains intact.

Edgartown (the village) is a tiny segment of that broad expanse: A cluster of houses, shops, and public buildings that, even by the most expansive of definitions, would fit comfortably within a square mile. An ambling pedestrian could cross the village in half an hour, a car (if unimpeded by summer traffic) in minutes. Over 375 years, however, the community within that space has changed, and been changed by, the wider world. This is its story.

One

THE SHIRE TOWN

1642–1820

Today, the image of Edgartown is as intimately, inextricably tied to the sea as that of Nantucket, Salem, or Gloucester. It was not always so. Working the sea was, until the early 1800s, one occupation among many followed by the residents of Edgartown. The sea helped to sustain life in Edgartown but did not define it.

What set Edgartown apart from Tisbury and Chilmark—until the late 1800s, the only other named townships on the island—was its status as the island's center of commerce, learning, and government. What most American states call a "county seat" is, in Massachusetts (as well as Vermont and Maine), a "shire town," and Edgartown has, from the earliest days, been the shire town of Dukes County. It was in Edgartown that the county sheriff, the clerk of courts, and the register of probate carried out their duties, and judges and lawyers came to Edgartown twice a year to hold sessions of the Superior Court.

The Dukes County Courthouse—center of legal, judicial, and administrative activity for the Vineyard, Nomans Land, and the Elizabeth Islands—stood first on North Water Street and then at the corner of Cooke Street and Pease's Point Way. The county jail where malefactors were imprisoned and the stocks where they were publicly shamed were likely nearby. Edgartown is also a market town and the site of the island's first house of worship (the First Congregational Church, founded in 1642) as well as some of the island's earliest schools.

Edgartown village was, for residents of outlying parts of the township (and the rest of the island) a cosmopolitan center. To go there was to go "to town," and encounter (however modestly) the wider world.

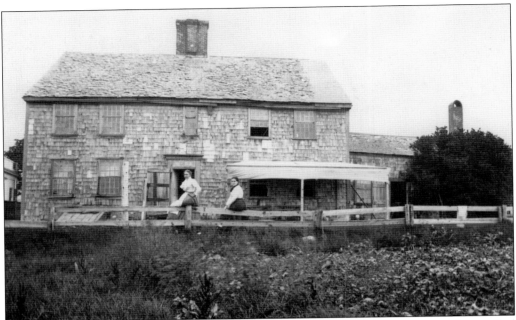

THE MAYHEW HOMESTEAD. The earliest European landowners in Edgartown—sometimes called "the five-and-twenty," Martha's Vineyard's equivalent of Nantucket's "first comers"—built their homes on narrow lots extending inland from the west side of the harbor. Thomas Mayhew and his namesake son, leaders of the five-and-twenty, erected the family's first home on the island at what is now South Water Street. Decades later, after the younger Thomas had been lost at sea and his sons Matthew, Thomas, and John had stepped into the "family business" as magistrates and missionaries, the family erected a larger home (shown here) on the same site. Built in 1670, it lasted until 1910.

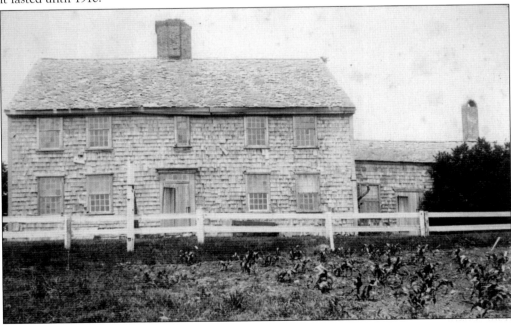

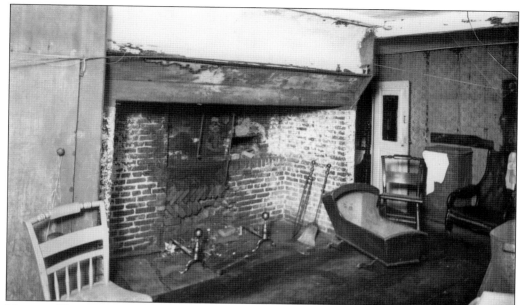

MAYHEW HOUSE HEARTH. Typical of New England homes of its era, the Mayhew House's rooms were organized around large brick fireplaces vented through a central chimney. When not being used for roasting, simmering, and baking (the rectangular door of a small built-in oven is visible above the right-hand andiron), the hearth remained a focus of family life, since its banked fire was the home's principal source of heat.

THE VINCENT HOUSE. Built in 1672, the Vincent family's homestead was less grand than the Mayhews' (with a sleeping loft in place of a full second floor) but shared its hearth-centered design. The small annex on the right is a summer kitchen, used in months when surplus heat from cooking was a curse rather than a blessing.

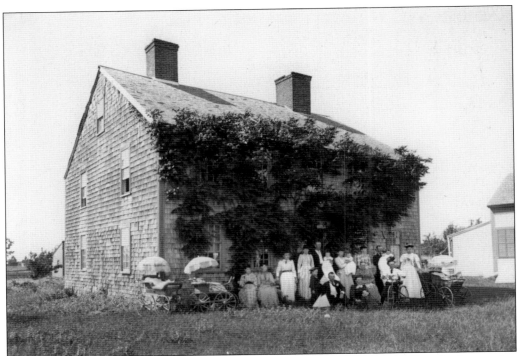

PARSON THAXTER'S HOUSE. Called to the pulpit of the First Congregational Church after serving as chaplain to Washington's army, Rev. Joseph Thaxter ministered to the people of Edgartown for nearly 50 years. His home stood at the northwest corner of Cooke Street and Pease's Point Way, just steps from the meetinghouse where he preached.

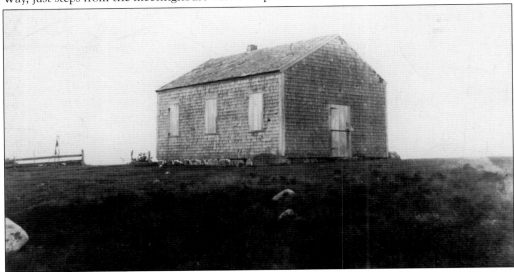

PUBLIC BUILDINGS AND AUSTERITY. Parson Thaxter's meetinghouse, though larger than this one on Chappaquiddick, shared its design philosophy of simplicity, frugality, and austerity—a legacy of the Congregationalists' Puritan roots. Other public buildings, like the county courthouse and jail, were equally modest. Like virtually all of Edgartown's 18th-century homes, they were sheathed in cedar shingles—a durable substitute for costly paint.

THE COOKE HOUSE. Built around 1740 by Temple Phillips Cooke, one of Edgartown's first attorneys, this two-story home reflects his success and that of his son and grandson, both named Thomas and both prominent Edgartown lawyers. Thomas Cooke Jr. also served as collector of customs for Edgartown during the early national period, possibly using one of the house's bedrooms as the customs office. Sold out of the family in 1851, the house was acquired in 1930—unmodernized and little changed from its colonial appearance—by the Dukes County Historical Society, forerunner of the Martha's Vineyard Museum.

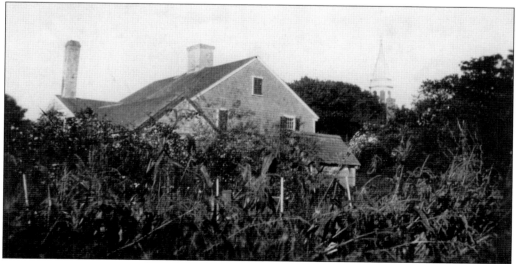

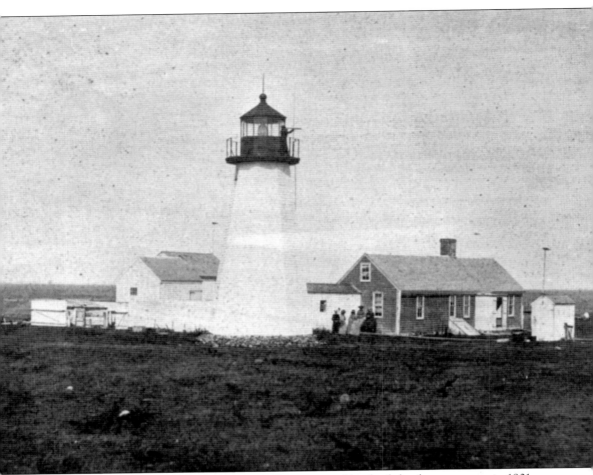

CAPE POGE LIGHT. The lighthouse at Cape Poge, erected by the federal government in 1801, was the first (and for a generation the only) structure in Edgartown built with off-island money. Like its sister light at Gay Head, it was established for the benefit of the thousands of ships that passed through Vineyard Sound and Nantucket Sound each year, enabling them to fix their position and warning them of the treacherous shoals and currents that surround the island. Keeping the Cape Poge Light's oil lamp burning was the responsibility of a lone keeper who lived with his family in an adjacent two-room house, their profound isolation broken only by occasional visits from supply ships and inspectors. Trips into town for supplies or medical assistance were arduous and rare: the nine-mile round trip over windswept dunes or unpredictable waters had to be completed in time to light the lamp at dusk.

Two

THE WORLD THE WHALEMEN MADE

1820–1870

Long before the village of Edgartown was a famous whaling port, European residents of the town—like the Wampanoag before them—were harvesting whales from the surrounding seas. Town records from 1652 record the appointment of Thomas Daggett and William Weeks as "whale cutters" for the coming year, responsible for butchering any whales that washed onto Edgartown beaches. Later, not content to wait for whales to come to them, Edgartown mariners put out from shore in small boats to chase them in the sound.

Offshore whaling—voyages of many months in oceangoing ships capable of carrying multiple small boats and storing the fruits of the hunt—came later. The first recorded whaling voyage from Edgartown began in 1765, when the schooner *Lydia* left Edgartown for the Davis Strait between Greenland and the Canadian Arctic. Success bred ambition, and in Nantucket, Edgartown, and other New England ports, larger ships were fitted out and longer voyages planned. Months away from home stretched into years, and hundreds of barrels of oil taken blossomed into thousands.

Whaling was dirty, difficult, dangerous work; a significant portion of the young men who signed onto one whaling voyage thought better of making a second. With the risks, however, came opportunities few landsmen could ever dream of. A man who was both talented and lucky could be a mate at 21, a captain at 25, and retired by his early 40s, flush with cash to invest in a farm or business and a fine home. Edgartown fielded its own fleet of whaleships—the *Loan*, the *Almira*, the *Splendid*, the *Ocmulgee*—but its sons sailed as seamen and harpooners, mates and masters, on literally hundreds of others.

The money that Edgartown whalemen brought home built the houses, churches, and public buildings that today symbolize the whaling era of Edgartown's history. The whaling industry depended, however, on scores of more prosaic buildings: wharves and storehouses, blacksmith's and cooper's shops, hardtack bakeries, and candle factories. Those workaday structures have long since vanished, undocumented and all but forgotten; only the white-painted glory remains.

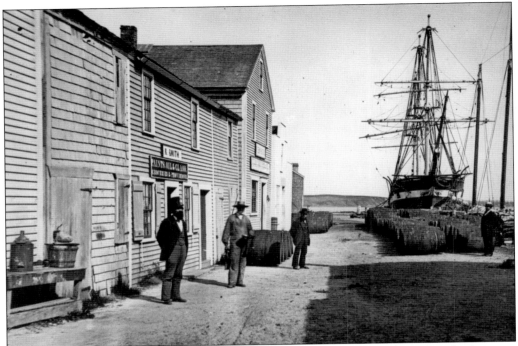

OSBORN'S WHARF. Wharves were practical necessities for the whaling industry but also lucrative investments for wealthy residents of Edgartown. Samuel Osborn Jr., whose family built the wharf at the foot of Main Street, was also the town's leading owner of whaleships and one of its wealthiest residents. Here, in 1871, the Osborn-owned *Splendid* loads supplies for a voyage.

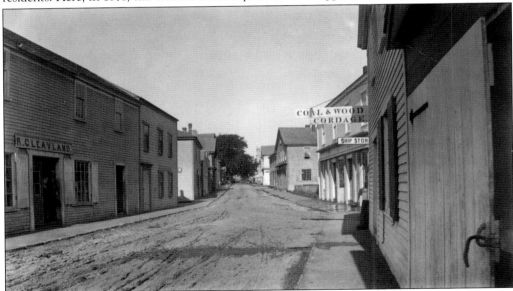

LOWER MAIN STREET. The land abutting Osborn's Wharf, like virtually all of the Edgartown waterfront in the 1800s, was jammed with businesses and buildings that served the whaling industry. A blacksmith shop and a ship chandlery selling mariners' essentials stood, along with storehouses and fish markets, on land now occupied by the town parking lot.

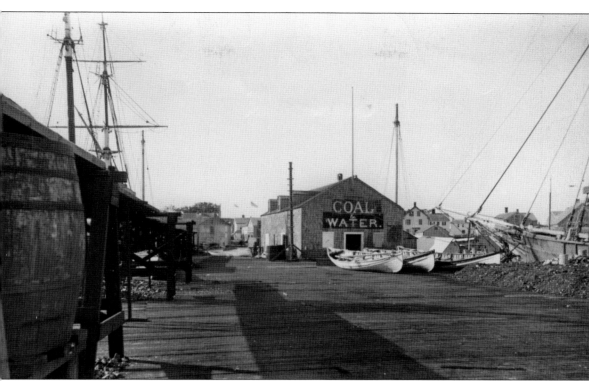

INDUSTRIAL DISTRICT. Chadwick's Wharf, at the foot of Mayhew Lane, was built to serve the needs of whaleships, and the tools of that trade—oil barrels and whaleboats—are clearly visible in this photograph from the 1880s, alongside a coal pile representing a newer business venture. Chadwick's was one of five major wharves—from Collins Wharf at the foot of today's Cooke Street to North Wharf at the foot of today's Morse Street—that formed Edgartown's densely packed waterfront industrial district. Practicality and convenience trumped aesthetics on the waterfront, and beauty was sacrificed for efficiency. Dr. Daniel Fisher's oil-and-candle works, located opposite his wharf—rebuilt by the town and now called Memorial Wharf—was the single largest and most lucrative business on the waterfront. It produced 118,000 candles and 13,000 barrels of refined whale oil in 1850 alone, products valued at more than $275,000.

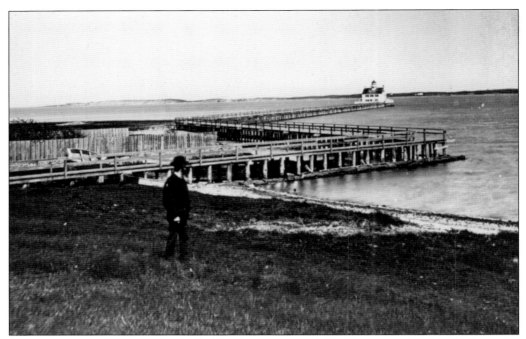

THE "BRIDGE OF SIGHS." The footbridge that connected the Edgartown Harbor Light to the shore below North Water Street was built in 1830, two years after the lighthouse itself, for the convenience of the lighthouse keeper. It soon became—according to legend—a favorite spot for the women of the town to wave a last farewell to the ships carrying their lovers or husbands away to sea.

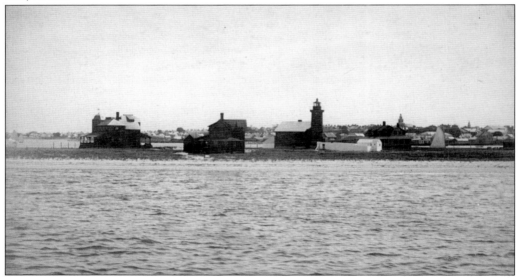

NANTUCKET WATERFRONT. Nantucket was the heart of the New England whaling industry in the early 1800s, but by the 1840s, a slowly accreting sandbar made it impossible for oceangoing ships to enter its harbor. In response, local ship owners sent their captains to Edgartown to take on supplies at the beginning of the voyage and unload their oil at the end. Nantucket's loss became Edgartown's gain.

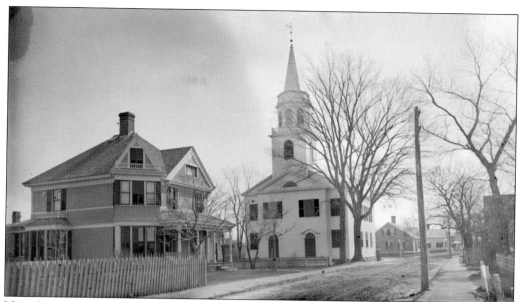

NEW CONGREGATIONAL MEETINGHOUSE. The 1828 Congregational Meetinghouse, one of many new public buildings built during the boom years of the whaling industry, reflected the opulence and heady optimism of the era. Built by master carpenter Frederick Baylies Jr., son of the last missionary to the Wampanoag, it faced Main Street across a then-unobstructed green.

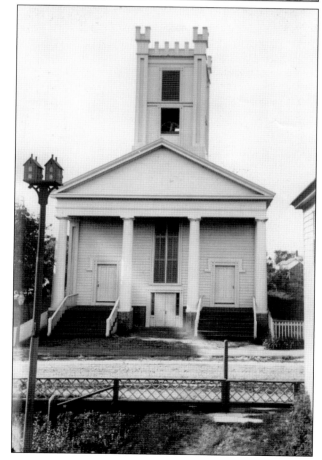

BAPTIST CHURCH. The First Baptist Church of Edgartown, another Baylies design, split the difference between the conspicuous plainness of the Congregationalists' old meetinghouses and the soaring belfry-and-steeple design of their newest one. The Baptist congregation that commissioned it in 1839 would, a century later, merge with its Congregationalist brethren to form the Federated Church of Edgartown.

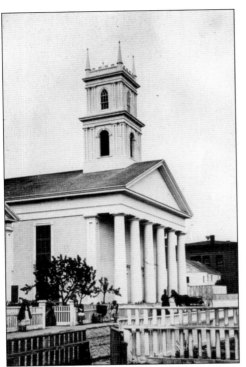

WHALING CHURCH. The First Methodist Church, better known as the Whaling Church, acquired its name because the money to build it was pledged almost entirely by whaling captains. The fourth and final Edgartown church designed by Frederick Baylies Jr., it opened in 1843 and replaced an earlier meetinghouse (now the town hall) that he had designed for the congregation in 1828.

WHALING CHURCH INTERIOR. The church's towering second-floor sanctuary featured trompe l'oeil murals on its walls and ceiling. Executed by itinerant German artist Carl Wendte, who did similar work at churches in Provincetown and Nantucket, they were painted over later when the cost of maintaining them exceeded available funds. The section behind the altar was reconstructed in 2013 by Edgartown muralist Margo Datz using this 1865 photograph.

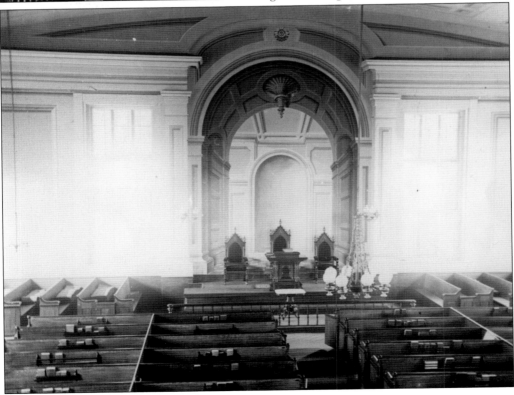

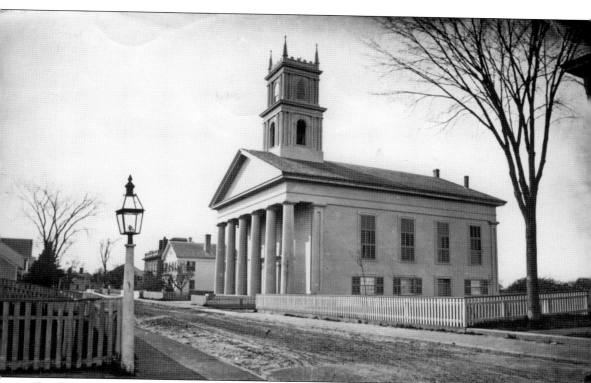

THE WHALING CHURCH AND METHODISM. The Whaling Church's prominence on Main Street reflected Methodism's prominence in the spiritual life of Edgartown. The first Methodist on the island had arrived little more than 50 years earlier, in 1787. Charles Banks's *History of Martha's Vineyard* describes him as John Saunders, a former slave from North Carolina who preached to the Wampanoag and other people of color first at Farm Neck and then on Chappaquiddick, where he had moved after the death of his wife. The new century had brought revivalists like "Reformation John" Adams, whose fiery preaching excited worshipers, won converts, and alarmed Congregationalist pastors like Rev. Joseph Thaxter, who had had the island to themselves since the days of the first Mayhews. Methodism grew steadily as the 19th century unfolded, buoyed by annual summer camp meetings beginning in 1835 at Wesleyan Grove—now the center of Oak Bluffs but then (and for 45 years to follow) part of Edgartown.

VIEW FROM WHALING CHURCH. The tower atop the Whaling Church, 92 feet high, provided an ideal spot for the town clock and an irresistible vantage point for photographers, including the one who recorded this view in the mid-1880s. The Daniel Fisher house, with its distinctive octagonal cupola, is visible in the left foreground, along with the large barn that once stood behind it. The two-story white building with a tower in the middle distance is the North School, opened in 1850 and used to house the town's younger pupils. South School, several blocks away on School Street and thus to the left of the photographer, accommodated older students, including those who attended through high school. The Fisher barn and the South School are long since gone, but the North School building remains, now part of the Vineyard Commons complex on Mill Street.

CHAPPAQUIDDICK SCHOOLHOUSE. The North and South Schools, which served the children of Edgartown village, were beyond the reach of families in outlying parts of the town. Those areas were served by one-room schools like this one on Chappaquiddick. The schools at Pohogonut, Eastville, and The Plains, along today's West Tisbury Road, were similarly modest.

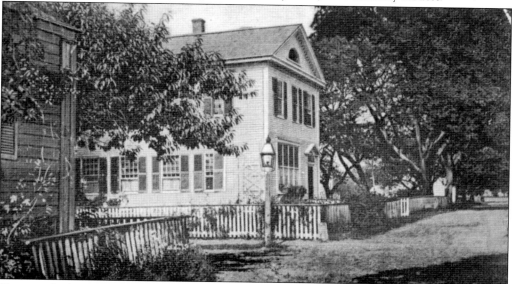

THAXTER'S ACADEMY. Prosperous Edgartown families also had the option of sending their children to private schools. Thaxter's Academy, at the corner of School Street and Davis Lane, was founded in 1825 by Rev. Joseph Thaxter's Harvard-educated son, Leavitt. On the opposite corner of the intersection was Davis Academy, operated from 1835 to 1850 by attorney and future state representative David Davis.

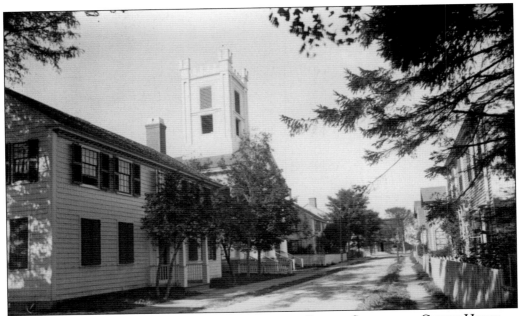

SCHOOL STREET AND COFFIN HOUSE. Whaling money funded a building boom that, by 1850, provided work for 41 carpenters and smaller numbers of other tradesmen. Jared Coffin, among the most successful, built his own house on School Street in 1823, adjacent to the Baptist church designed and built by his brother-in-law Frederick Baylies Jr.

CHARLES NORTON HOUSE DOORWAY. Many of the new houses of the whaling era used white-painted clapboards rather than cedar shingles, a nod to the architectural fashions of the day but also (because they required ongoing maintenance) a sign of prosperity. Elaborate architectural details, like those on Capt. Charles Norton's house, shown here, also signaled the homeowner's material success.

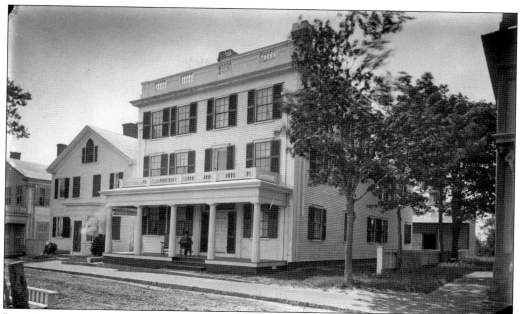

JARED FISHER HOUSE. Built in 1832 by Thomas Coffin for Capt. George Lawrence, the house at 86 North Water Street was sold—possibly even before it was finished—to Capt. Jared Fisher. The spermaceti candle factory of Dr. Daniel Fisher (page 27; no relation) stood across the street.

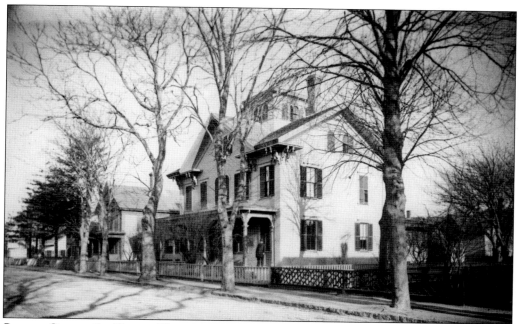

SAMUEL OSBORN JR. HOUSE. The owner of several buildings on Main Street and Osborn's Wharf at its foot, as well as several whaling ships, Osborn was one of Edgartown's most prominent businessmen and one of its leading political figures. His house, built in 1865, is now part of the Charlotte Inn.

CLAPBOARD STYLE. Surviving colonial houses (including the Old Mayhew House) and solid-but-modest middle-class homes mingled with the captains' mansions on North and South Water Streets. The Herman Arey house at 2 South Water Street, whose doorway is shown here, is an example of the latter, built by a furniture maker.

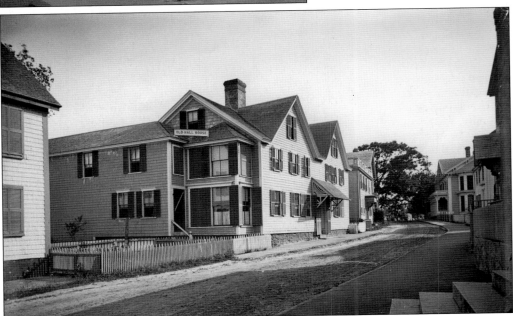

THE OLD HALL HOUSE. Taking in boarders, a common practice on the Vineyard in the 1800s, enabled householders—particularly widows or the wives of mariners absent on extended voyages—to use empty rooms to generate much-needed income. Once a boardinghouse, the Hall House on South Water Street is now part of the Harborside Inn.

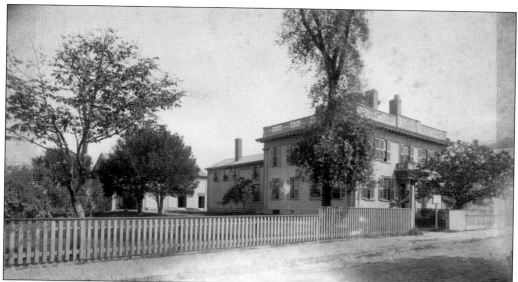

THE DANIEL FISHER HOUSE. The largest house, and the largest fortune, in whaling-era Edgartown belonged not to a captain or ship-owner but to Dr. Daniel Fisher, whose shore-based business enterprises supported the whalers. Fisher, who came to the island as a physician, became Edgartown's principal whale-oil merchant, buying up incoming ships' cargoes of oil and—after grading, refining, and repackaging it—selling it to off-island buyers. He also owned a harbor-front factory that turned spermaceti into high-quality candles and a bakery that sold hardtack (a form of hard biscuit whose durability made it a staple of sailors' diets) to ships fitting out for long voyages.

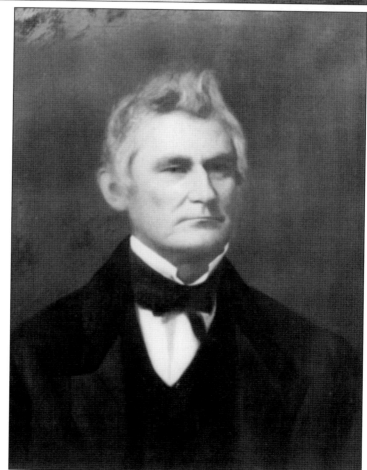

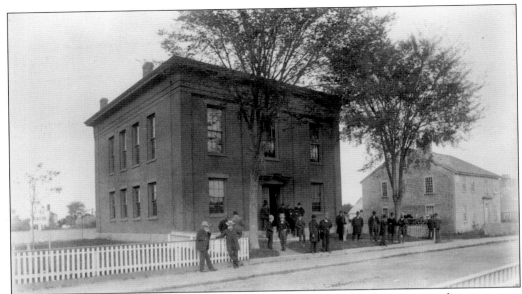

DUKES COUNTY COURTHOUSE. Erected on Main Street in 1858, the new courthouse was an imposing symbol of the law's power and the town's newfound prominence. It was the second brick building in Edgartown and among the first on the island, following the Edgartown National Bank (page 60) by three years and the Gay Head Lighthouse by two years.

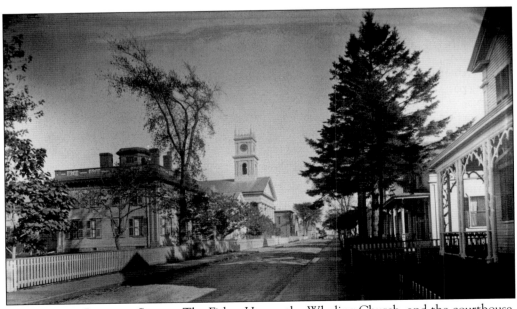

MAIN STREET LOOKING SOUTH. The Fisher House, the Whaling Church, and the courthouse, along with the homes that faced them across Main Street, formed a kind of ceremonial gateway to the town for visitors arriving from Tisbury or up-island. They represented the gleaming aspirations of whaling-era Edgartown, and the rough-hewn buildings along the waterfront represented the prosaic reality.

Three

AN UNCERTAIN FUTURE
1870–1895

The whaling industry died by slow degrees. There was no one moment of blinding clarity when the citizens of Edgartown grasped that the town's future would have to be sustained by an economy different than that which had sustained its past. Finding that elusive foundation for the future took an entire generation.

The Civil War struck the first blow. Whaling was an overwhelmingly Northern, uniquely Yankee enterprise, and whaleships (especially those already laden with a high-value cargo of oil) represented a massive concentration of Yankee cash in tangible form. Destroying them, as Confederate commerce raiders like the *Shenandoah* and *Alabama* did, struck a tangible blow against the Northern economy.

Whaling voyages continued after the war, but the whalers' success (and the resulting shortage of whales) drove them ever deeper into the waters of the Bering Sea, which added ice to the usual hazards of whaling. Late in 1871, twenty-four whaling vessels from the New England fleet tarried too long past the end of the Arctic summer and were trapped and crushed by ice. The *Mary* and *Champion* of Edgartown were lost, along with other vessels with Vineyard crews.

The hardest blow, however, was struck neither by war nor weather but by technological change. The discovery of oil in Pennsylvania and Texas, and the resulting rise of the petroleum industry, undercut the demand for whale oil by providing cheaper, mineral-based substances for illumination and lubrication. Whalers shifted their attention from oil to the tough, flexible baleen that whales used to filter plankton from the water, but the days of high profit margins and easy money were over forever.

Fishing and farming remained viable, of course, even as the profits from whaling dried up, but tourism seemed, to many of Edgartown's leading citizens, to be the key to the future. Cottage City, in the northern reaches of Edgartown, swelled each summer with thousands of tourists eager to spend their money on hotels, restaurants, and attractions. Edgartown village desperately needed their largesse; the question was how to attract them.

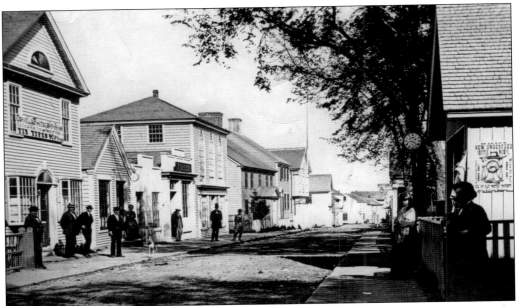

MAIN STREET, 1870. Edgartown was still growing, and businesses were continuing to replace the houses that had once filled the middle blocks of Main Street. Enoch C. Cornell, Edgartown's first professional photographer, opened his studio in Gothic Hall (center) in 1858 and moved to rooms over William Vinson's store (left) in 1861.

COMPLIMENTS OF

C. H. SHUTE & SON,

PHOTOGRAPHERS

AND PUBLISHERS OF

STEREOSCOPIC VIEWS,

23 Main St., Edgartown, and 16 Montgomery Square, Camp Ground.

We are publishing Views of the best quality of Martha's Vineyard Camp Ground, Highlands, Oak Bluffs, Gay Head, Edgartown, Katama, Vineyard Haven, Nantucket, A Whaling Voyage, Groups, Corals, Shells, &c. You should have a View of the *Hermit of Nantucket*, showing the *Interior of his House*. Views of Cottages, Tents and Groups taken at short notice.

We have also for sale at our Rooms, Stereoscopes, Picture Cord, Knobs, Screw Eyes, Velvet, Gilt and Black Walnut Frames. **Pictures Framed to Order.**

A very good assortment of Chromos large and small. Don't forget the place or name.

C. H. SHUTE & SON, **No. 16 MONTGOMERY SQUARE,**

Between the Central House and Arcade.

RICHARD SHUTE: PHOTOGRAPHER. Richard H. Shute became Cornell's principal competition in 1863. After his release from Union army service as a drummer and bugler on a medical discharge, he formed a partnership with his father, Charles, and opened a studio above the latter's Main Street store. Many of the pre-1900 photographs in this book are likely the Shutes' work.

LAURA JERNEGAN'S ADVENTURE. The late 1860s were late autumn for the whaling industry. Edgartown whalers, who had grown up in the trade, could still see the possibility of wealth and adventure beneath the hard work and long separations from loved ones. Motivated perhaps by such feelings, Capt. Jared Jernegan took his wife, Helen, and two young children—Laura (six) and Prescott (two)—aboard the whaler *Roman* when he departed New Bedford in December 1868 for a voyage to the Pacific. The family sailed together for three years, with Helen and the children remaining in Honolulu while Jared took the *Roman* to the Bering Sea. Laura's journal of her adventures, a rare child's-eye view of the whalers' world, is the basis for the Martha's Vineyard Museum's website www.girlonawhaleship.org.

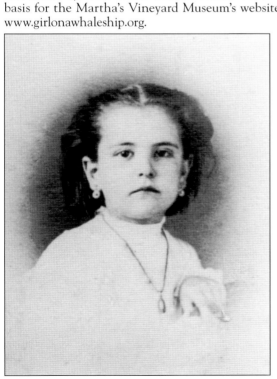

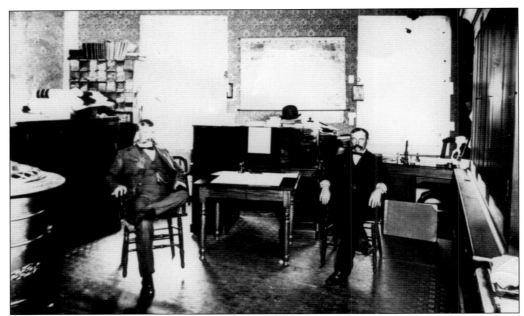

CUSTOMS OFFICE. The customs office grew in size and prominence during Edgartown's boom years, but by the 1870s, the traffic it handled was rapidly diminishing. Its second-floor suite of rooms overlooking Main and Water Streets, occupied here by collector John Wesley Pease (left) and assistant Charles M. Marchant, was closed in 1912.

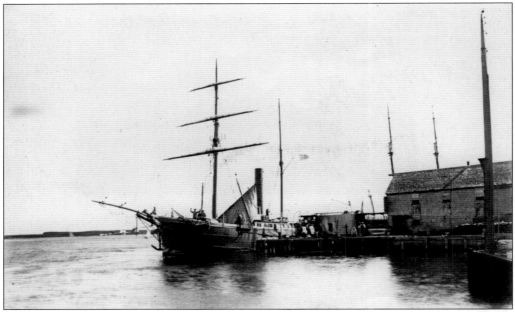

REVENUE CUTTER *GALLATIN*. The federal laws that Edgartown's customs collectors administered were enforced on the high seas by US Revenue-Marine cutters like the *Gallatin*, shown here docked at Osborn's Wharf. Regular visitors to Edgartown in the first two-thirds of the 19th century, the cutters called less frequently as mainland cities like Boston eclipsed Edgartown as ports of entry for ships entering US waters.

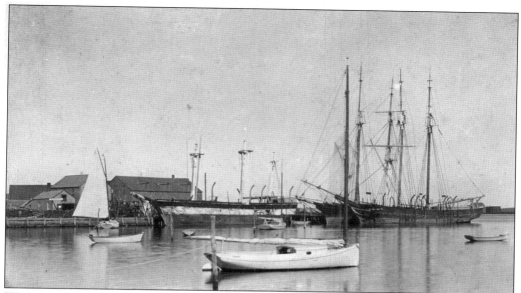

WHALERS AND FISHERMEN AT OSBORN'S WHARF. Ship owners who were also wharf owners, like Samuel Osborn Jr., had the advantage of keeping their vessels close at hand, incurring only the intangible opportunity cost of occupying space that might be used by paying customers. Here, the *Mattapoisett* (left) shares space with transient fishing and cargo schooners.

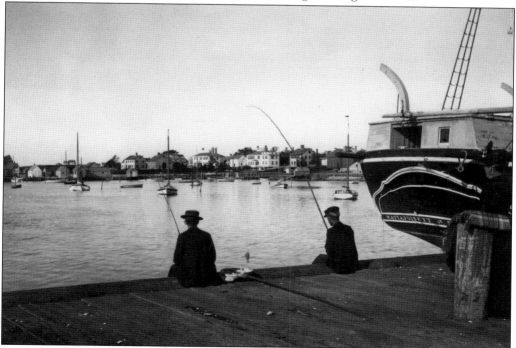

MATTAPOISETT, IDLED. Whaleships also became increasingly uncommon sights in Edgartown as the 1870s gave way to the 1880s. Those still in the harbor, like the *Mattapoisett*, often stood idle. Whaling was always a financial gamble, and owners preferred an idle ship to voyages that returned minimal profits or none at all.

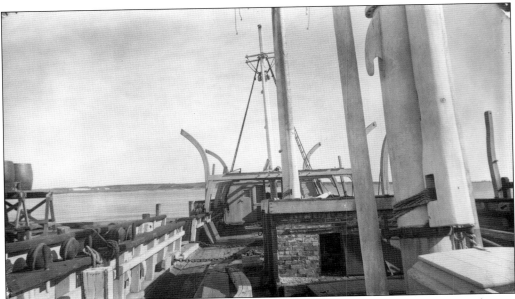

A Decommissioned Whaling Ship. Whaleships taken out of service for extended periods were often left in far-from-shipshape condition. The vessel shown in these two Shute photographs, probably the *Mattapoisett*, has been stripped of its upper masts, yardarms, and the rigging used to support them. The sails, whaleboats, and rigging used to raise and lower them have been transferred to other ships or placed in storage. The ship's tryworks, an on-deck furnace used to render oil from the blubber of butchered whales, has been dismantled, and one of the two iron try-pots it once held lies discarded on the deck. More than a hulk but less than a ship, the vessel thus requires minimal maintenance but can be restored to service quickly.

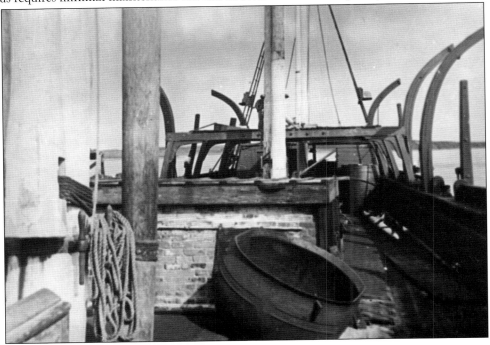

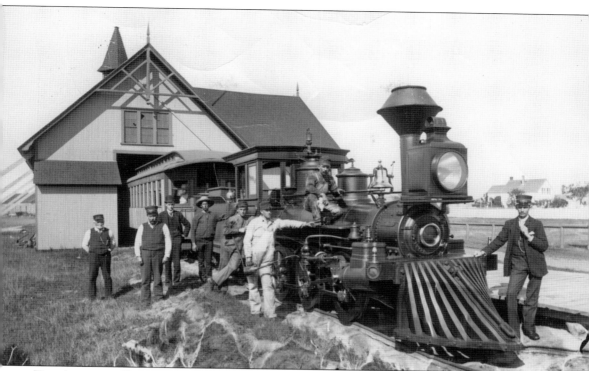

THE ACTIVE AT DEPOT CORNER. Established in 1872, the Martha's Vineyard Railroad linked Edgartown village to the booming summer resort of Cottage City with nine miles of narrow-gauge track, a small steam locomotive, and three cars. Tourists could step off a steamer at the Cottage City wharf and onto a train that would take them to the Edgartown Depot, a "pull-through" station at the intersection of Pine and Main Streets, near where the Depot Corner gas station stands today. Funded largely with whaling money and backed by some of Edgartown's leading citizens, the railroad was intended to simplify the logistics of traveling from Cottage City to Edgartown, encouraging tourists to make the trip. An extra enticement was added the following year, when the line was extended southward to serve Mattakeset Lodge, Edgartown's first resort hotel, located on Katama Bay.

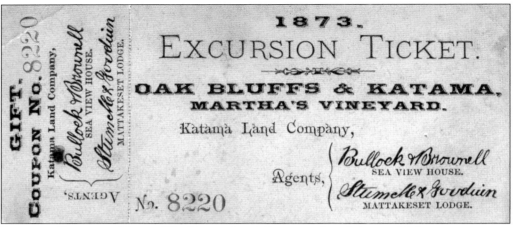

RAILROAD EXCURSION TICKET. The Katama Land Company, founded to establish a summer resort community on the sandy plains south of Edgartown village, operated separately from the railroad but in concert with it. Excursion tickets like this one were offered free to selected visitors in the summer of 1873 in hopes of raising awareness and interest.

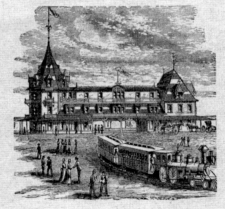

MARTHA'S VINEYARD RAILROAD.

On and after MONDAY, July 10, 1882, trains will run as follows: Leave Oak Bluffs for Edgartown, Katama, and South Beach, 8.15, 10.00 a. m., 12.30, 4.00 and 7.15 p. m. Tuesdays, Thursdays and Saturdays, and during the Baptist and Methodist Camp Meetings, an extra train will leave Oak Bluffs at 10.00 a. m. Leave Edgartown for Katama and South Beach, 8.30, 10.20 a. m., 12.50, 4.20 p. m. Leave Katama for South Beach, 8.45, 10.30. a. m., 1.00, 4.30 p. m. Return, leave South Beach for Katama, Edgartown and Oak Bluffs, 11.25 a. m., 1.45 and 5.30 p. m. Leave Katama for Edgartown and Oak Bluffs, 5.45, 8.45, 11.45 a. m., 2.35 and 5.45 p. m. Leave Edgartown for Oak Bluffs, 6.00, 9.00, 11.55 a.m., 2.45, 6.00 p. m. Tuesdays, Thursdays and Saturdays, and during the Baptist and Methodist Camp Meetings, an extra train will leave Edgartown for Oak Bluffs at 8.10 p. m.

SUNDAY TRAINS.—Leave Oak Bluffs for Edgartown, Katama, and South Beach, 11.15 a. m., 3.45 and 10.00 p. m. Return, leave South Beach for Katama and Oak Bluffs, 12.00 m., 5.00 p. m. Leave Katama for Edgartown and Oak Bluffs, 9.15 a. m., 1.15, 5.30 p. m. Leave Edgartown for Oak Bluffs, 9.30 a. m., 1.25 and 5.45 p. m.

☞ CLAM BAKE. ☜

On and after July 10th, a Genuine Rhode Island Clam Bake and Shore Dinner will be served daily at Katama, on arrival of train leaving Oak Bluffs at 12.30 p. m., Sundays, 11.15 a. m. The Pavilion was built expressly for this purpose, and is not surpassed for coolness and comfort by any like structure. The clams served here are guaranteed to be equal in flavor to Providence River, and a great many pronounce them to be superior. The clams, lobsters, fish, etc., are all cooked in the old Indian style, on heated stones. Parties leaving Oak Bluffs on 10 o'clock train, will have forty-five minutes at South Beach, one hour and a half at Katama, giving ample time to see the beauties of both places, eat an unrivalled shore dinner and return to Oak Bluffs at 2.35.

Fare for round trip, Oak Bluffs to Katama, 50c. Oak Bluffs to South Beach, 60c. Fare from Oak Bluffs to Katama and return, including Shore Dinner, 90c. South Beach, $1.00.

G. A. CARPENTER, Agent M. V. R. R.

MATTAKESET LODGE, KATAMA, M. V.

MATTAKESET LODGE BROCHURE. The new resort hotel in Katama catered to overnight visitors, but its advertising, like this leaflet from 1882, also targeted day-trippers. Visitors could take in the views of Katama Bay, ride the train to the end of the line at South Beach, or enjoy a lavish clambake with seafood prepared in "the old Indian style."

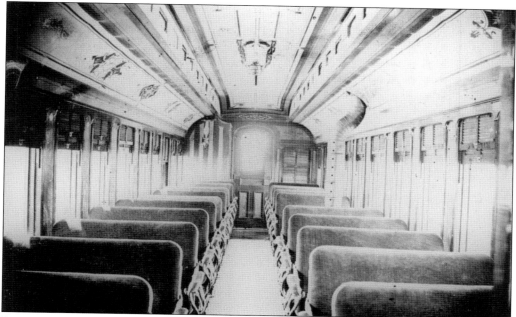

INSIDE THE *OAK BLUFFS*. The railroad's two passenger coaches offered substantially different amenities. The *Oak Bluffs*, shown here, was fully enclosed, with plush seats and overhead lighting, while the *Katama* traded comfort for a better view, with outward facing wooden bench seats and open sides that could be covered by roll-down isinglass windows in inclement weather. (Courtesy of the Delaware State Archives.)

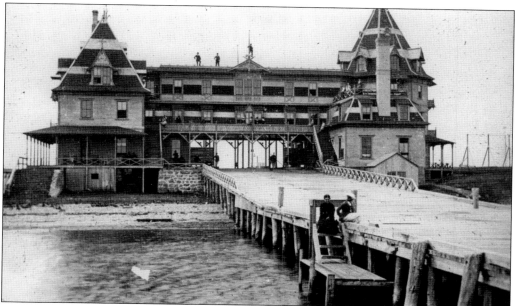

MATTAKESET LODGE AND PIER. The Sea View House, the northern terminus of the line, looked out over the often-stormy waters of Nantucket Sound, but Mattakeset Lodge nestled against the shore of calm, shallow Katama Bay. The locomotive *Active* was brought to the island in 1872 and removed in 1896 using temporary rails laid on its wharf.

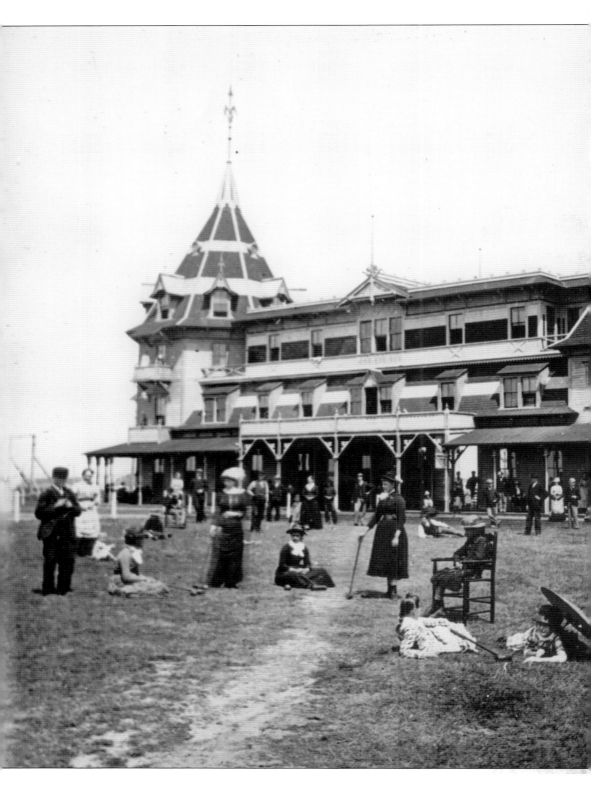

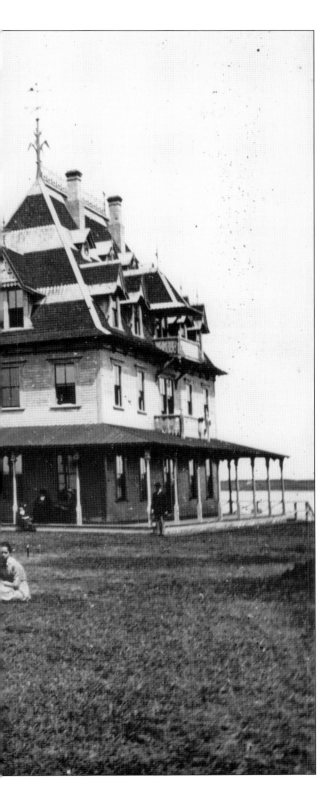

MATTAKESET LODGE. The design of Mattakeset Lodge was typical of late-19th-century seaside resort hotels like the Sea View and others then being built in Cottage City. It used towers, turrets, and spires to give it a fairy-castle quality that drew the visitor's eye and suggested opulence within. Plentiful windows and extensive porches and balconies enabled guests to enjoy the sea breezes that were for many a key attraction. Large open spaces on the ground floor provided room for dining, dancing, and socializing—essential, since (unlike those in Cottage City) the hotel was distant from other sources of entertainment.

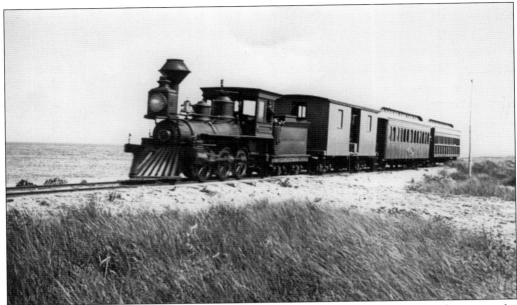

RAILS ON THE BEACH. Built along the barrier beach between Cottage City and Edgartown, the tracks of the Martha's Vineyard Railroad were repeatedly washed out by winter storms, requiring costly repairs that outstripped the income from its limited three-month operating season. The railroad shut down in 1896, and Mattakeset Lodge—too distant to draw the crowds its backers had hoped for—closed in 1905.

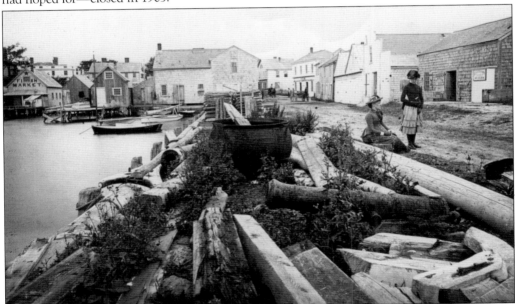

A DYING WATERFRONT. Along with the tepid public response to the Mattakeset Lodge and the financial troubles of the Martha's Vineyard Railroad, Edgartown faced a third, larger problem in its struggle to reinvent itself. Its utilitarian waterfront, designed around the needs of a dying industry, was itself falling into decay. A new one, designed to appeal to tourists and summer residents, was vital but slow in coming.

Four

BUILDING A
SUMMER RESORT
1890–1920

The lands that stretched from the northern boundary of Sengecontacket Pond to the tip of East Chop and from the eastern shore of the lagoon to Nantucket Sound were, politically and administratively, part of Edgartown. In every other way that mattered, however, they were a world of their own: geographically isolated and culturally separate.

That sense of apartness—of separation from the wider world—drew Methodist pilgrims as early as the mid-1830s. They returned summer after summer in ever-greater numbers to worship beneath the oak trees. Over the course of 30 years, tents became cottages and an encampment became a summer community. The Baptists followed the Methodists, and in the years just after the Civil War, the developers followed them both. A secular resort—parks and bathing beaches, roller rinks and carousels—wrapped itself around the older, inward-looking religious enclaves.

Cottage City, which declared its independence from Edgartown in 1880 and renamed itself Oak Bluffs in 1907, demonstrated the economic returns that could be reaped by becoming a summer resort. It did little, however, to provide a readymade model for becoming one. Oak Bluffs had been Martha's Vineyard's first (and only) planned community, laid out on all-but-undeveloped ground according to a unified master plan drawn up by its developers. Edgartown village, in contrast, was already dense with homes, businesses, and public buildings; its waterfront was still thick with vessels, sheds, and wharves. The summer resort facilities that were Edgartown's future would have to be interleaved with the many layers of its past.

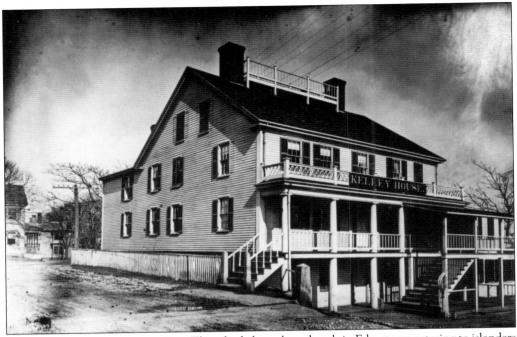

KELLEY HOUSE AND COLONIAL INN. There had always been hotels in Edgartown catering to islanders on overnight business and itinerant sailors in search of a night ashore. The Kelley House (above) opened its doors in 1742, and luminaries such as Daniel Webster and Nathaniel Hawthorne stayed at what is now the Edgartown Inn. The new hotels built at the turn of the 20th century, like the 1911 Colonial Inn (below), offered the expansive public spaces and amenities that summer tourists had come to expect. Fulfilling those expectations, however, required space to build.

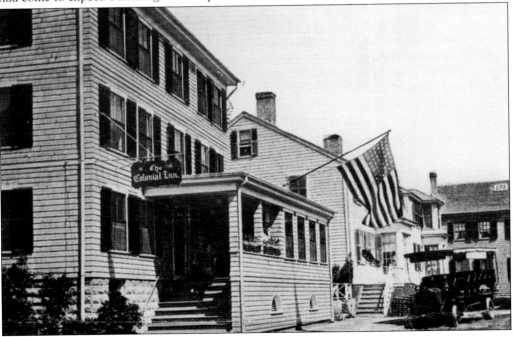

NORTH WHARF. Located at the foot of what is now Morse Street, North Wharf marked the boundary of Edgartown's commercial waterfront. Beyond it, North Water Street stretched along Starbuck's Neck toward Eel Pond and the sound. Captains' houses lined its landward side, and green space sloped toward the harbor on its seaward side. It offered the openness of Katama without the isolation.

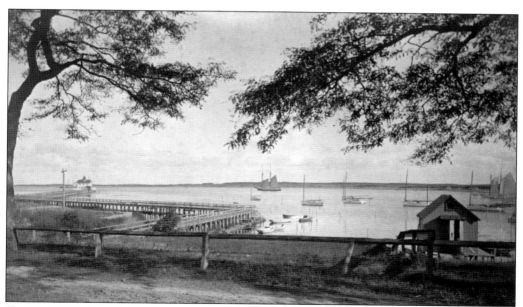

VIEW FROM NORTH WATER STREET. The footbridge to the Harbor Light began its zigzagging path out to sea from land below North Water Street, and the sidewalks—as well as the bridge—offered unspoiled views of the lighthouse, the harbor, and Chappaquiddick beyond. It was here that the cornerstone of Edgartown's growth as a summer resort was laid.

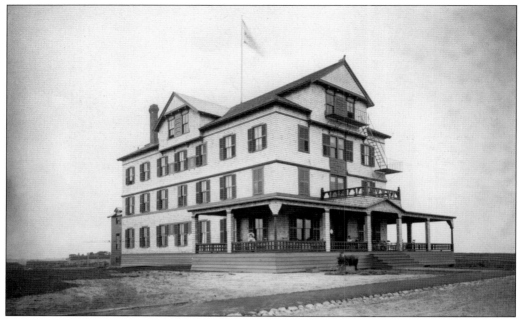

THE HARBOR VIEW. The Harbor View was the first resort hotel built in Edgartown village, but—as this photograph taken shortly after its 1891 opening suggests—"in" was a relative term. The hotel stood on the northern outskirts of the village, at the far end of North Water Street, surrounded by open land. Yet, like the lighthouse bridge, it was only a brief, brisk walk from the village center.

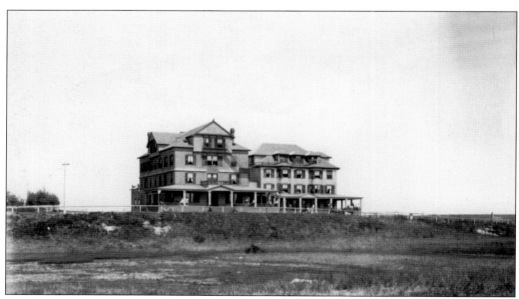

THE HARBOR VIEW, EXPANDED. Despite a nationwide financial crisis (the Panic of 1893) that triggered one of the deepest depressions of the 19th century, the Harbor View did well enough that, in little more than a decade, it was able to expand. The new addition—seen here on the right side of the building—incorporated a portion of the Mattakeset Lodge, then being torn down.

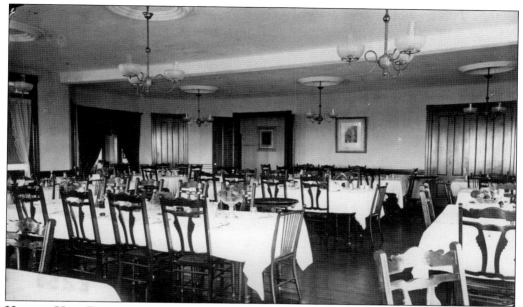

Harbor View Dining Room. There had always been hotels in Edgartown—the Kelley House, established in 1742, served itinerant sailors and visiting Superior Court judges alike—but the Harbor View was the first specifically designed to cater to the summer resort trade. Its spacious dining room served guests who, having booked their rooms on the American plan, expected to eat all three meals at the hotel.

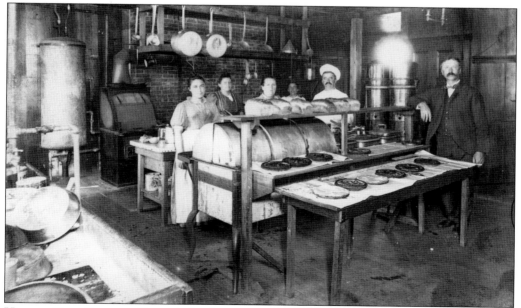

Harbor View Kitchen. Beneath the dining room lay an elaborate kitchen that offered seasonal employment to a large staff. Here, Chef Clark (second from right) poses with members of his staff, including his wife (third from left), who served as pastry cook. Owner Frank A. Douglas (far right) began his career at the hotel as manager and bought out the original owners after the Panic of 1893.

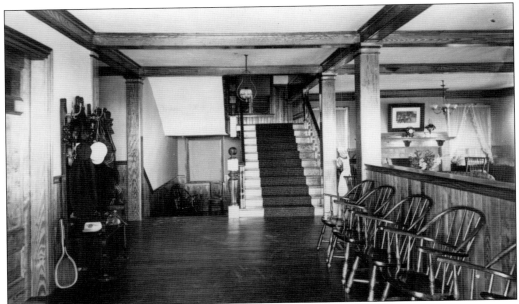

HARBOR VIEW LOBBY. The spaciousness of the Harbor View's public areas, including its wide front porch, conveyed an air of relaxation and slow-paced recreation not always present in earlier hotels converted from private homes. The tennis racket leaning against the wall to the left suggests the range of recreational activities for which the surrounding lawns could be used.

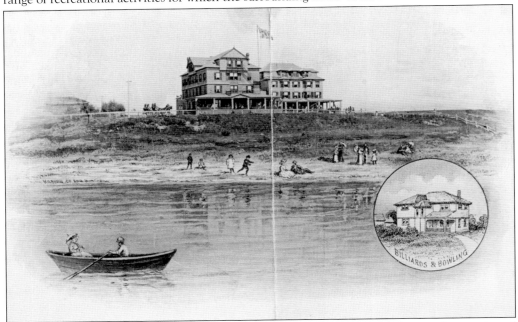

WATERFRONT RECREATION. The Harbor View's expansive lawns provided space for tennis and other games, but the beach and shallow waters in front of the hotel were a prime attraction of the site for adventurous rowers and "sea bathers" like those shown in this 1890s advertisement. The heavy wool bathing costumes of the time made sedate wading and floating more common than active swimming.

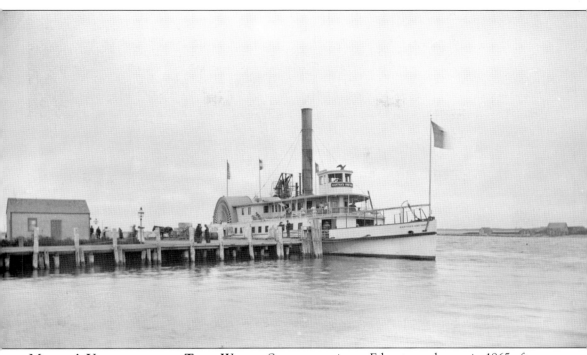

MARTHA'S VINEYARD AT THE TOWN WHARF. Steamer service to Edgartown, begun in 1865 after several unsuccessful attempts in earlier decades, gave visitors from the mainland direct access to the village. Disembarking at the Town Wharf, passengers were minutes away from a half-dozen different hotels, including the Harbor View and (after 1911) the Colonial Inn at the head of Kelley Street. The steamers, operated by the New Bedford, Martha's Vineyard & Nantucket Steamboat Company, plied the long run from Fairhaven (where they connected with Old Colony Line trains from Boston) to Nantucket. Edgartown, like Vineyard Haven and Cottage City, was a stop along the way. Wood-paneled and velvet-cushioned, the steamers lent an air of luxury to a necessary (and, in stormy weather, not always comfortable) journey.

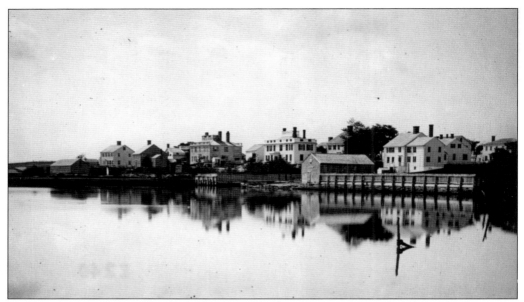

WATER STREET "COTTAGES." The harbor-front lots along Water Street, prized above all others since the days when Thomas Mayhew allotted them to the five-and-twenty, remained so as Edgartown embraced its new identity as a summer resort. The year-round houses built (or expanded) by whaling captains and ship-owners were rebuilt (or further expanded) into vacation homes for the new summer visitors.

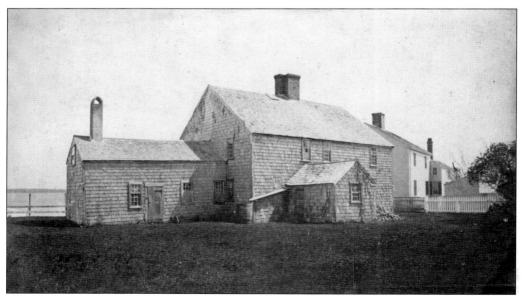

THE OLD MAYHEW HOUSE. Edging into its third century, the Old Mayhew House had become famous: a landmark depicted on scores of postcards and mentioned in every guidebook. It was also increasingly out of place: a gray-shingled, swaybacked relic surrounded by trim, gleaming summer homes like those visible at far right. Deemed beyond repair, it was demolished in 1910.

JOHN COFFIN HOUSE. Not all of South Water Street's ancient houses were swept away by turn-of-the-century construction. Buried inside the oft-remodeled home at 55 South Water Street, for example, are the bones of a single-story, shed-roofed building, 32 feet by 24 feet, built in 1682—the home and workshop of Nantucket-born blacksmith John Coffin.

COFFIN HOUSE PORCH. The new summer vacation homes, meant to be occupied for only three or four months of the year, were designed to allow their owners to take every advantage of those months and the (mostly) fine weather they afforded. Broad, open porches with furniture that could be stored inside in the off-season and expansive windows that could be covered with shutters or boards were commonplace.

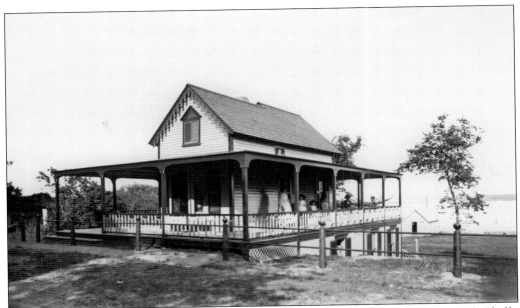

NORTON COTTAGE FRONT. Like the summer cottages that lined Ocean Park in Oak Bluffs, whose turrets, balconies, and jig-sawed gingerbread trim consciously echoed the smaller cottages surrounding the Methodist Tabernacle, summer homes in Edgartown generally mimicked the white-clapboard elegance of the town's whaling-era homes. Architectural whimsy occasionally crept in, however, as in this Water Street home, more porch than house.

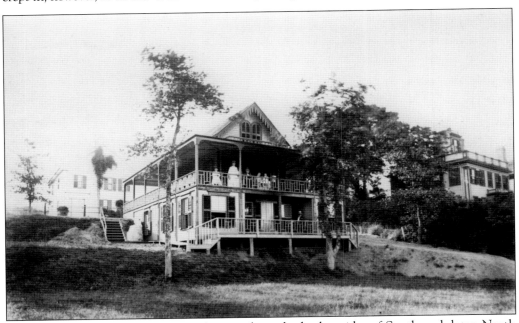

NORTON COTTAGE REAR. Vacation homes along the harbor sides of South and, later, North Water Streets were often designed to take advantage of the sloping land on which they stood. Downstairs living spaces opened onto porches and patios that led to sloping lawns with piers, boathouses, and beaches at their feet.

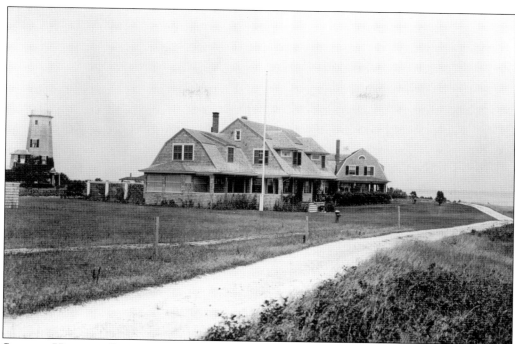

SUMMER HOME ON STARBUCK'S NECK. Summer residents who built (or remodeled) residences in outlying areas of the village could create more expansive homes than those whose in-town lots were hemmed in by existing roads and structures. This one, beyond the Harbor View on Starbuck's Neck, echoes the sprawling, gray-shingled style of houses built around the same time, and in similarly unconstrained settings, on East Chop and West Chop.

CHAPPAQUIDDICK COTTAGE. Chappaquiddick, still predominantly rural in the early 1900s despite its proximity to Edgartown village, became popular with summer residents attracted to the quiet and isolation it offered. Plans to create a Cottage City–style planned community at Wasque failed to materialize, but individual vacation homes began to rise among the farmhouses.

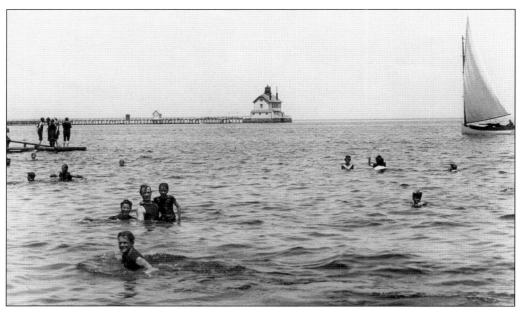

SWIMMERS OFF CHAPPAQUIDDICK. Tourists and summer residents alike—even those who had no desire to rent (let alone live) there—still found Chappaquiddick a congenial place to visit. Its sandy bathing beach, across the channel from Edgartown village, became a favorite destination for sea-bathers visiting Edgartown, who could splash in the shallow, sheltered waters while gazing at passing ships and, in the distance, the Edgartown Harbor Light.

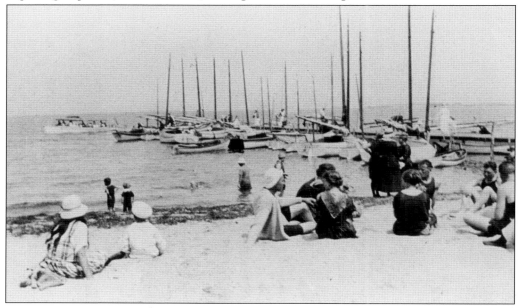

CHAPPAQUIDDICK BEACH. The Chappaquiddick side of the harbor, unencumbered by the buildings, wharfs, and piles of stored gear that filled the Edgartown side, was developed into a seaside playground for summer visitors. The bathing beach, established in 1883, replicated in miniature the more elaborate facilities available in Cottage City: bathhouses, piers, and amenities like floats and diving platforms for adventurous swimmers.

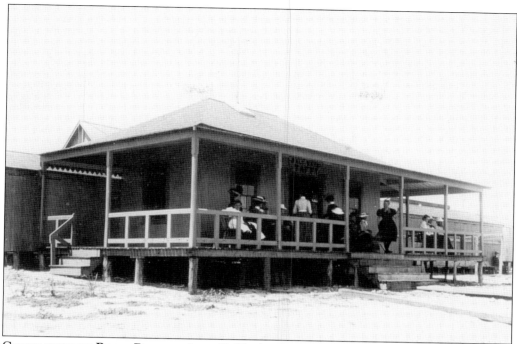

CHAPPAQUIDDICK BEACH PAVILION. James E. Chadwick, son of bathing beach founder Edwin Wells Chadwick, had been an investor in the Martha's Vineyard Railroad. The turn-of-the-century beach pavilion shown here is said to have been the waiting room and ticket office from the Edgartown Depot, moved to Chappaquiddick after the railroad shut down.

CHAPPAQUIDDICK MOTOR LAUNCH. The *Charlesbank*, shown here in the 1920s, was a steam-powered launch that ferried visitors across the harbor to the pier at the bathing beach. Like the pavilion, it too was repurposed: it had originally been an officer's gig from a US Navy battleship, complete with a white canvas awning, richly varnished wooden brightwork, and polished brass hardware.

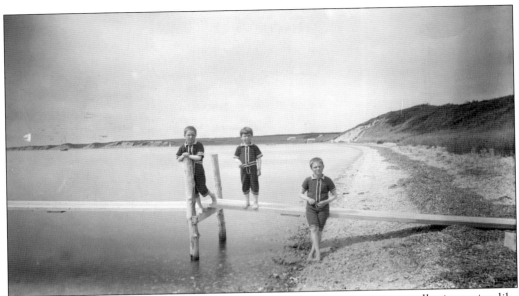

BOYS ON DOCK. As recreational boating became a popular summer activity, small private piers like this sprouted along the edges of the harbor. They allowed passengers to walk from lawn to deck while keeping their feet free of sand, salt, or seaweed, a desire that would likely have mystified the boys pictured here.

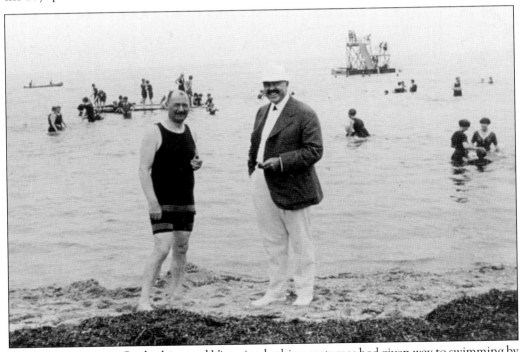

NATTY BEACHGOERS. Sea bathing and Victorian bathing costumes had given way to swimming by 1920 and swimsuits that allowed their wearers bare arms and greater freedom of movement. The suits still hid more than they revealed, however, and street clothes were still standard beachwear for those who—like the man on the right—had no interest in getting wet.

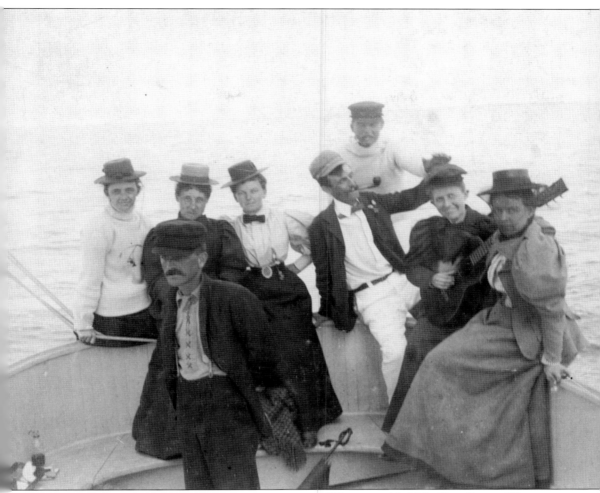

GROUP ON PARTY CATBOAT. Trips to more remote parts of Chappaquiddick like Cape Poge or Wasque for beach picnics, or simply touring the harbor under sail, were popular summer recreation. Many local fishermen who pursued scallops, mackerel, and cod in the offseason stored their gear ashore and scrubbed out their catboats for summer, offering their services to tourists seeking maritime adventures. "Party cats," as they were sometimes called, appealed particularly to casual visitors and to summer residents who lacked the skills, interest, or funds to maintain a boat of their own. Here, Capt. Harry Norton (foreground) takes a high-spirited group of passengers sailing aboard the catboat *Clara* around 1900. Seated behind him are Mary Norton (far left), Jennie Owen (third from left, in bow tie), Winslow Wilson (third from right), and Charles S. Norton (in rear), along with three unidentified friends of Jennie Owen.

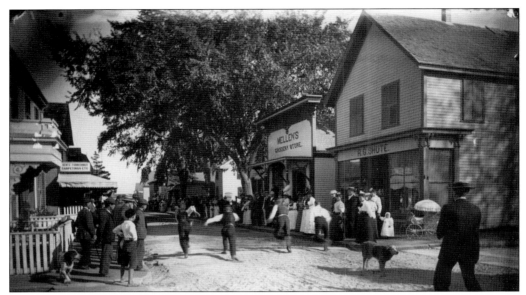

FOOTRACE ON MAIN STREET. In the village as well as at the shore, transformation into a summer resort brought a more playful spirit to Edgartown. Here, in 1893, boys participating in an athletic competition sprint down the center of Main Street in the finals of the 100-yard dash. The winner, Laura Jernegan's youngest brother, Marcus, was awarded a sweater valued at $3.

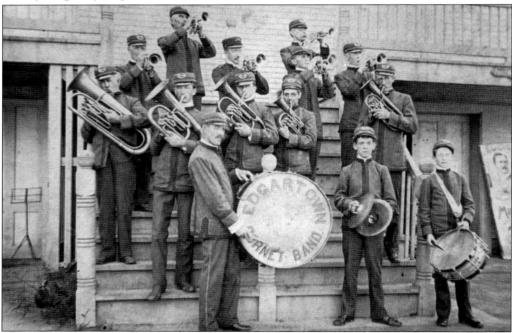

CORNET BAND. Richard G. Shute (top row, left) returned to Edgartown after Civil War service as a musician in the Union army, becoming (in partnership with his father, Charles) a successful photographer and shopkeeper. He remained interested in music, however, founding and leading the Edgartown Cornet Band, posed here on the steps of the town hall before its last summer concert of 1902.

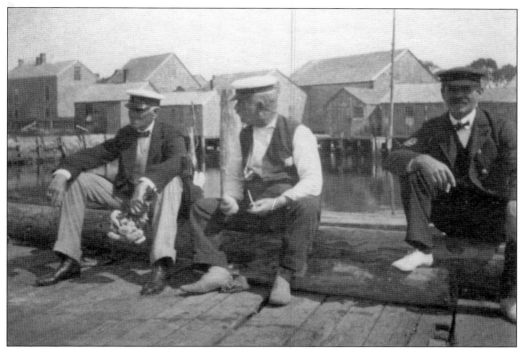

YACHTSMEN RELAXING ASHORE. Edgartown remained a working seaport well into the 20th century, but its passenger steamers, cargo schooners, and fishing boats shared space with the pleasure craft of summer visitors. Yachtsmen like these from the 1910s—in their immaculate blazers, flannel trousers, and peaked caps—represented the new face of the waterfront.

THE BIRTH OF A YACHT CLUB. Founded in 1905 in a building at the foot of Main Street, the Edgartown Yacht Club brought together those—mostly summer residents—whose interest in the sea was recreational rather than professional and who sailed in vessels far larger and more comfortable than the working schooners and catboats that filled the harbor (chapter five).

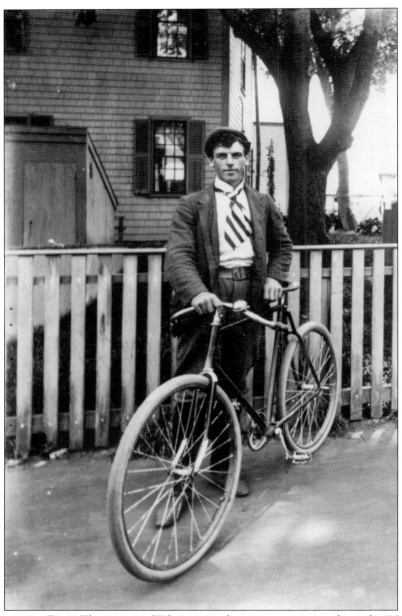

YOUNG MAN WITH BIKE. The paving of Edgartown's downtown streets in the early 1900s, though done to accommodate the growing number of automobiles on the island, was a boon to the entire town, residents and visitors alike. It kept down dust in the summer (eliminating the need for cumbersome water-spraying rigs mounted on the backs of wagons) and eliminated the seas of mud that formed on rainy days between the already-paved sidewalks and crosswalks. As had been the case in Cottage City a decade earlier, paved streets also drew the attention of "wheelmen:" mostly young, mostly male cyclists who pushed their pneumatic-tired "safety bicycles" to dizzying speeds wherever they could find smooth-surfaced public ways to ride on. The young cyclist shown here is believed to be Marcus Jernegan, champion sprinter (page 56) and future professor of American history at the University of Chicago.

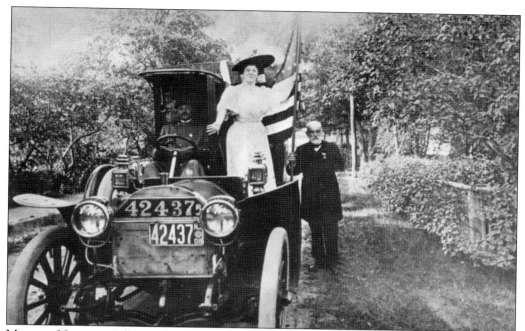

MADAME NORDICA. Lillian Allen Norton, whose great-grandparents had left Edgartown to settle in Farmington, Maine, made a triumphant visit to the island early in the new century. One of the foremost dramatic sopranos of her generation, she was famous not only as a singer but also as a model for Coca-Cola advertisements.

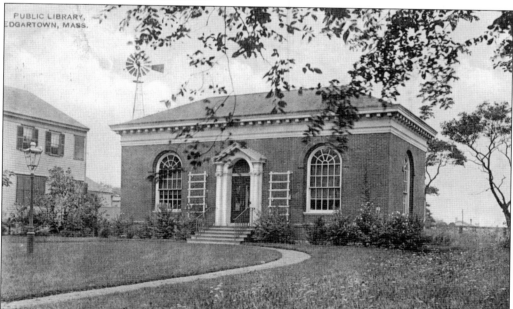

THE CARNEGIE LIBRARY. After years of operating out of a second-floor storefront on Main Street, the Edgartown Public Library moved into new quarters on North Water Street in 1904. Built using funds donated by Pittsburgh steel tycoon Andrew Carnegie, it is said to be the smallest of the nearly 1,700 Carnegie libraries established in the United States between 1883 and 1929.

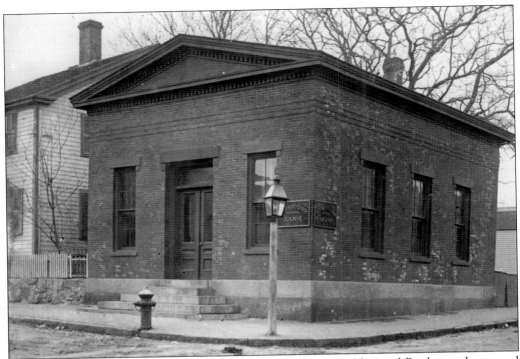

EDGARTOWN NATIONAL BANK. Opened in 1855, the Edgartown National Bank was the second established on the island. Its imposing brick edifice, designed to project security and stability, stood—like the post office and the headquarters of the *Vineyard Gazette*—at the intersection of Main and Water Streets, which had become the symbolic center of town.

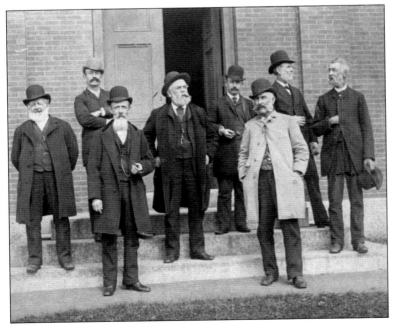

BANK TRUSTEES. The bank reflected the selective integration of summer people into the community. Its first board of trustees, posed here on its steps shortly after it opened, included cofounders Beriah Tilton Hillman (third from left), a member of an old island family with roots predating the Revolution, and Julien Whiting Vose (light-colored coat), a summer resident from Boston who had married Anna Pease of Edgartown.

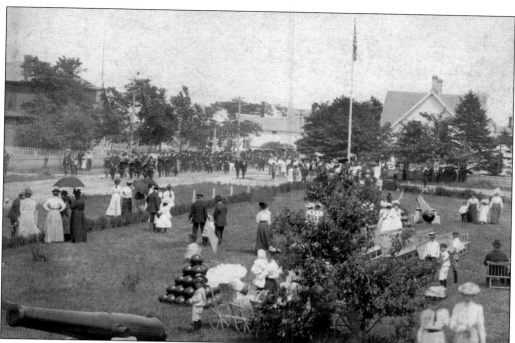

MEMORIAL PARK. Located on a triangle of land between Main and Cooke Streets, Memorial Park was dedicated on July 4, 1901. Its decorations—decommissioned naval cannons and pyramids of cannonballs donated by the Charlestown Navy Yard, near Boston—gave rise to the informal name bestowed on it by residents and visitors alike: "Cannonball Park."

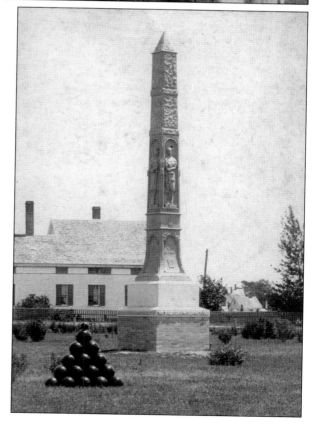

CIVIL WAR MEMORIAL OBELISK. The park is dominated by a tall metal-and-granite monument honoring the 70 Vineyard men who died in the Civil War. Among the names etched on it are those of two Edgartown brothers: Elisha Smith, who succumbed to wounds he suffered at Gettysburg, and Eliakim Smith, who died in a prisoner-of-war camp at Salisbury, North Carolina.

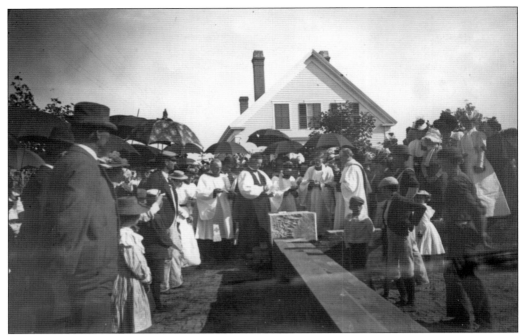

Laying the Cornerstone. The cornerstone for St. Andrew's Church, blessed by an Episcopal priest in full vestments, was laid on a bright summer day in 1899. Scores of future parishioners and curious onlookers turned out to watch and to inspect the work on the foundation that was already underway.

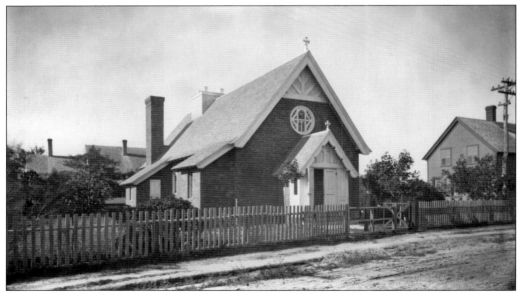

St. Andrew's Completed. The small church at the corner of Winter and Summer Streets was completed in 1899, the third brick building in the village. The bricks used to construct it came by ship from off-island, since the brickyard at Roaring Brook in Chilmark had shut down years earlier.

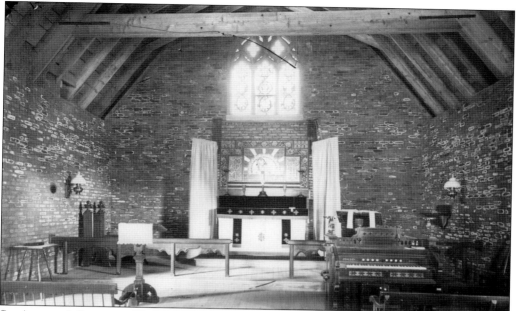

ST. ANDREW'S INTERIOR. Unfinished brick, exposed wooden beams, and simple benches for pews gave the sanctuary an atmosphere of rugged simplicity that echoed (without duplicating) that of the early colonial meetinghouses. A new, larger organ replaced the original one (shown here) in 1913, and two additional stained-glass windows, designed by Tiffany, were dedicated in 1927.

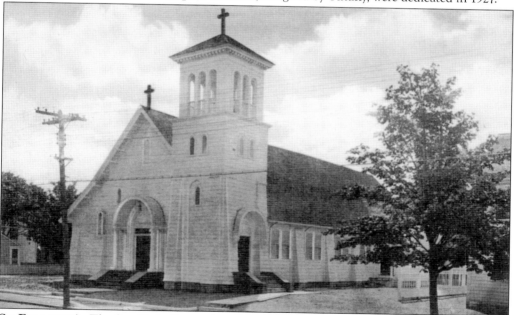

ST. ELIZABETH'S. The first Catholic parish in Edgartown, formed just after 1900, met in makeshift quarters on Pease's Point Way. By the early 1920s, it had outgrown them, and in 1924, the foundation was laid for a new, purpose-built church on Main Street. St. Elizabeth's opened its doors in 1925—the same year that the dwindling Congregationalist and Baptist congregations united to form the Federated Church.

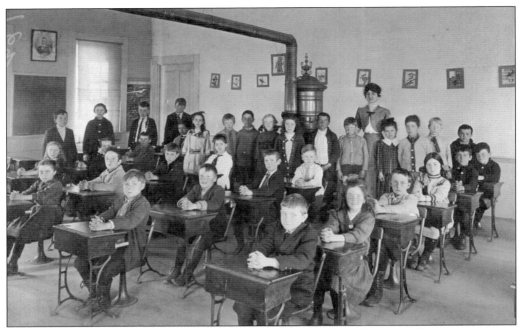

PUPILS AT NORTH SCHOOL. The North School (page 22) had been home to Edgartown's younger students for more than 60 years when these class photographs were taken in 1911. Above are students from the primary school, roughly grades one through three, while below are students from the grammar school, which then encompassed grades four through six. The woman at the back of the grammar school class is Osterville-born teacher Sarah Codding, then 25 and in her first year at the school. She died in Oak Bluffs in 1978 at the age of 93, still fondly remembered by those who had long ago been her charges.

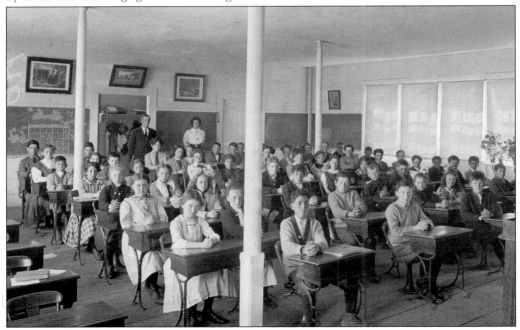

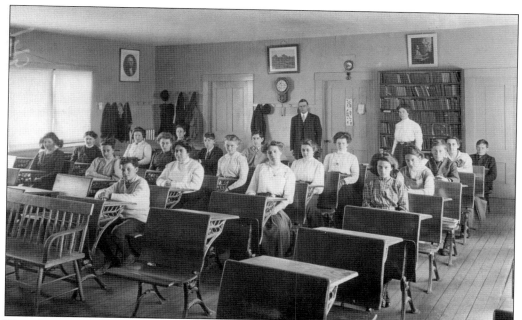

HIGH SCHOOL CLASS. South School, which opened at the corner of School and High Streets in the spring of 1850, was originally home to the intermediate school (which offered basic reading and writing instruction for pupils beyond normal grammar-school age) and the island's first public high school. By the early 1910s, when this photograph was taken, it hosted grades seven through twelve, graduating eight to ten students per year.

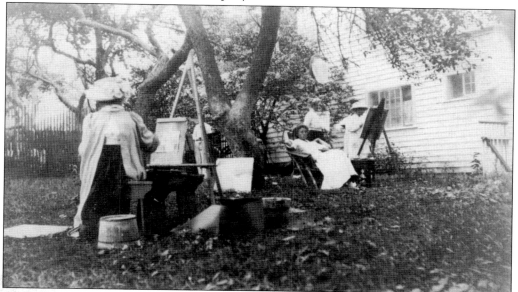

BRANSTOCK SCHOOL OF ART. Thaxter's Academy and Davis Academy were distant memories by the beginning of the new century, but in 1908, Enid Yandell, a New York artist noted for her sculptures, opened the Branstock School of Art in the old Thaxter building. The tree-shaded yard became a site for open-air painting classes, in which Yandell herself (seated) sometimes served as model.

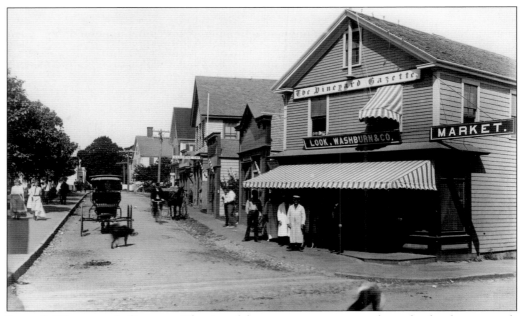

LOOK & WASHBURN'S GROCERY. The rise of the resort economy was a boon for shopkeepers such as Look & Washburn, whose grocery emporium was one of several in downtown Edgartown. On the second floor, Charles Marchant published the weekly *Vineyard Gazette* and ran a side business as a job printer producing handbills, letterhead, and government forms.

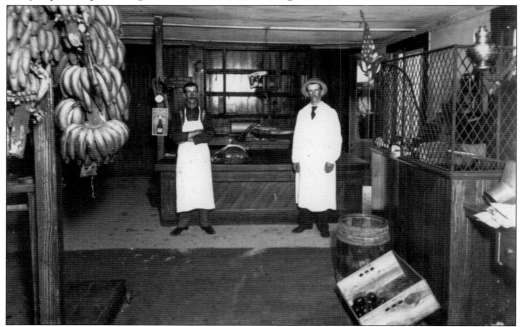

INSIDE THE CORNER MARKET. The interior of the Look & Washburn store reflects the retail practices of the era, with clerks pulling merchandise from shelves and bulk bins to fill customers' orders. Bananas, just completing their transition from exotic rarity to staple, hang near the front of the store; a butcher's counter, where meat is cut to order, looms in the rear.

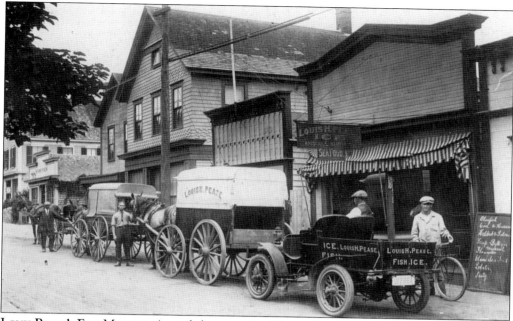

LOUIS PEASE'S FISH MARKET. An eighth-generation Vineyarder, Louis H. Pease operated two retail fish-and-ice markets in Edgartown and two more in Oak Bluffs, as well as delivering to more than 300 customers at the peak of the summer season. The North Water Street store was his flagship operation, supplied with fish from docks less than a block away.

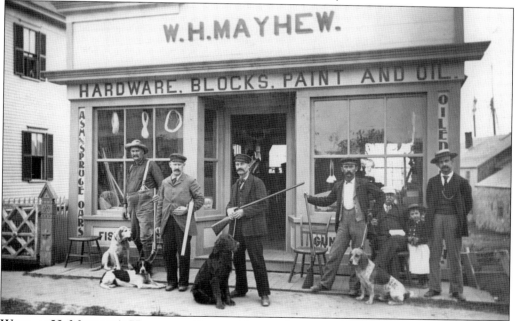

WILLIAM H. MAYHEW'S HARDWARE STORE. Alert to the opportunities offered by the new resort economy, Mayhew courted sportsmen at his small shop on North Water Street, advertising "ash and spruce oars" for yachtsmen, fishing tackle, and "gunner's supplies" for waterfowl hunters alongside traditional lines of hardware. As this image suggests, his flexibility was rewarded.

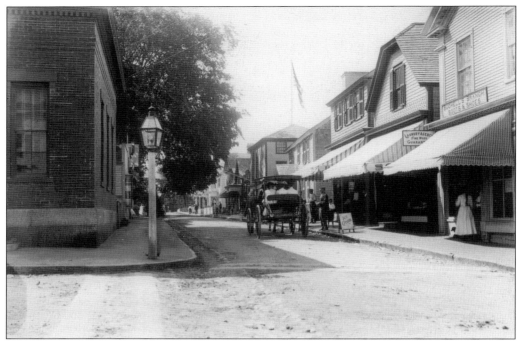

MAIN STREET BUSINESSES. Once a mixture of shops and houses, the three blocks of Main Street between the courthouse and Osborn's Wharf had by the early 1900s become a purely commercial district. Many of the stores, however, operated from buildings converted from, and still recognizable as, houses—a pattern that continues today.

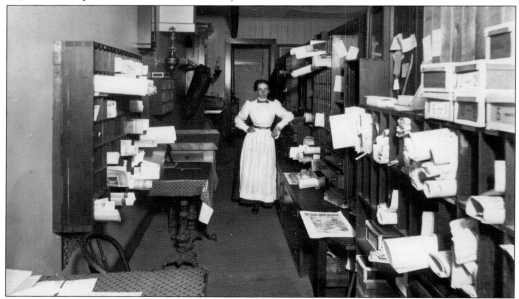

EDGARTOWN POST OFFICE. Occupying one of the four corners where Main and Water Streets met, the Edgartown Post Office—along with the bank, grocery, and newspaper office—made the intersection the de facto center of town. Behind the counter, sometime around 1900, Postmistress Mary Adlington surveys her domain.

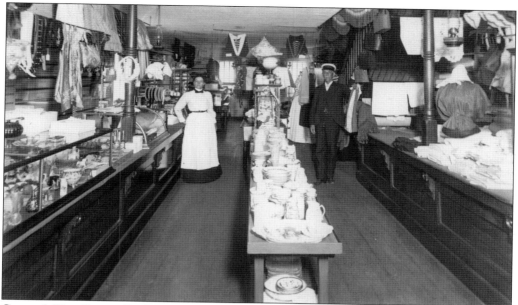

COTTLE'S DRY GOODS. Dealers in fabric, sewing accessories, ready-to-wear clothes, and household items such as linens and dishes, dry goods stores were—along with hardware and grocery stores—pillars of small-town shopping districts. The elaborate displays of china on Cottle's shelves suggest a conscious attempt to cater to well-to-do summer residents.

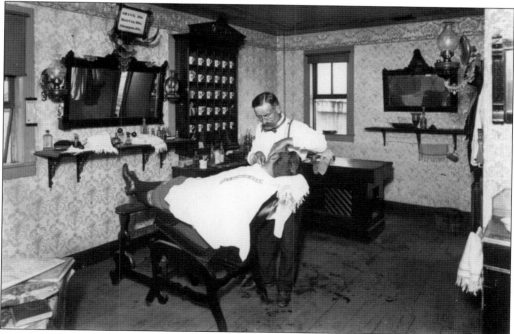

DEXTER'S BARBER SHOP. Barbershops filled a social role once played by taverns and saloons: a place where men could enjoy each other's company, exchange local gossip, and discuss the events of the day. They did so, however, without the moral stigma attached to establishments that served alcohol—a crucial advantage in a temperance-minded community like Edgartown.

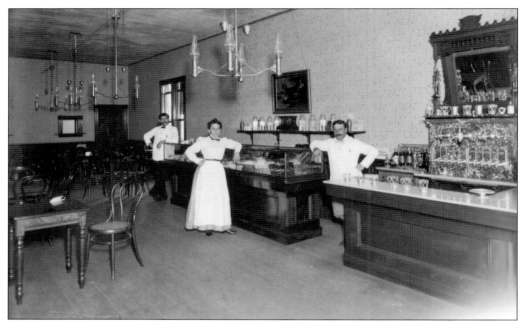

BUNKER'S ICE CREAM PARLOR. With its bentwood chairs and marble counters, Bunker's went to great lengths to present itself as a genteel establishment, suitable for respectable women and well-behaved children to patronize unescorted. The elaborate displays of glassware behind the counter suggest the range of frozen confections available to customers: sundaes, splits, shakes, and sodas.

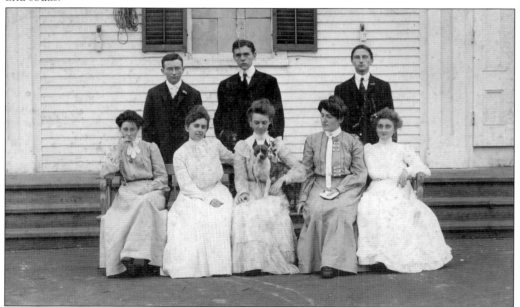

EDGARTOWN HIGH GRADUATES. When Edgartown was still mired in its post-whaling doldrums, a story in a Boston newspaper lamented that the young men of the town were obliged to leave in order to make their fortune. Prospects were brighter for the students in this Edgartown High graduating class from the early 1910s, if they were willing to embrace the new resort economy.

Five

A CHANGING WATERFRONT
1900–1940

Even after the last whaleship was tied to the wharf and stripped of its gear, a fading reminder of a world that had moved on, Edgartown still looked to the sea. Even after the last try-pots had been dragged ashore, scrubbed clean of blubber and smoke, and filled with bright flowers, it was still a harbor town. Even after the customs office had closed and the merchant brigs laden with exotic cargoes had given way to steamers packed with eager tourists, its harbor was still filled with sails.

The sailing vessels that passed through Edgartown between the end of the whaling era and the beginning of the Second World War were, with a handful of exceptions, built for work. Their crews netted mackerel in the sound and cod on the Grand Banks, harpooned swordfish south of Nomans Land, and dragged for scallops in Katama Bay. They hauled lumber and bricks, coal and oil, and salted fish and any other cargo that could be packed in boxes, barrels, or bales.

Decades after the Harbor View had begun to draw tourists to Starbuck's Neck, rows of bathhouses had sprouted along the Chappaquiddick shore, and the captains' houses on Tower Hill had been remade as summer-vacation homes, summer visitors shared Edgartown's waterfront with those who made their living from the sea. Sailing yachts anchored among fishing schooners, and cabin cruisers moored alongside catboats.

Over time, the balance between the two groups of users shifted, slowly but inexorably. As with the decline of the whaling era, the process was gradual, the turning points apparent only in retrospect. By 1940, however, the balance had shifted for good. Going forward, Edgartown Harbor belonged to the yachtsmen and the recreational sailors.

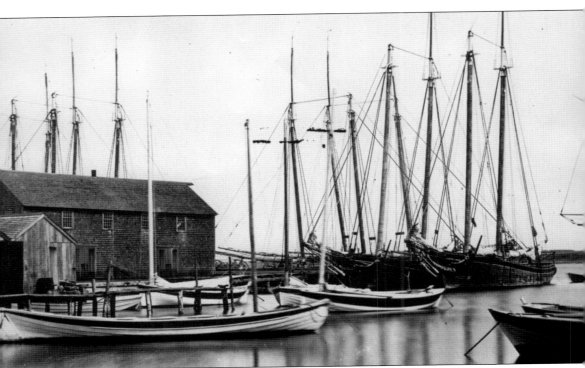

SCHOONERS. The decline of the whaling industry and the closure of the customs office meant that, by the late 1800s, large oceangoing ships no longer called at Edgartown. Schooners, however, remained plentiful. Rigged with sails set parallel to the long axis of the hull, rather than perpendicular, schooners were designed to be worked by very small crews. Even the largest of them seldom carried more than 10 sailors, and a typical two- or three-masted schooner could be handled by less than half that number. Slower than traditional square-rigged ships on long ocean passages with steady winds behind them, schooners came into their own in constricted, inshore waters where frequent changes of course were necessary to avoid underwater hazards or thread narrow channels. These qualities, along with their broad decks and relatively low sides, made them ideal working vessels capable of hauling bulk cargoes or handling nets heavy with fish.

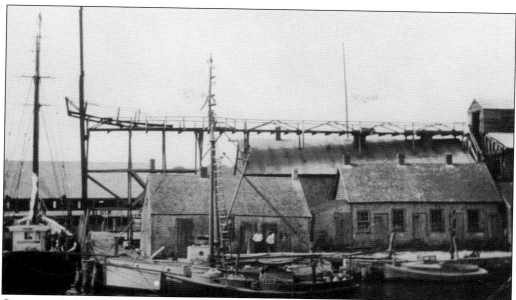

CHADWICK'S COAL WHARF. Schooners were peerless carriers of bulk cargoes like coal, for which low carrying cost mattered more than speed. Chadwick's Wharf, just north of Osborn's, acted as an intermediary between coal schooners and islanders who bought their cargo, with an unloading facility and a coal yard built directly on the wharf itself.

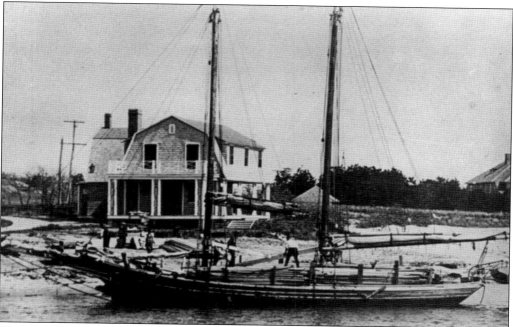

COASTING SCHOONERS. On routes between coastal destinations, schooners were frequently cheaper than railroads and—because they could land at any conveniently placed wharf—sometimes faster as well. In this photograph, taken shortly after the beginning of the 20th century, Capt. Zeb Tilton unloads a cargo of lumber from the *Winifred B. Fuller* at a building site in Harthaven, just south of Oak Bluffs.

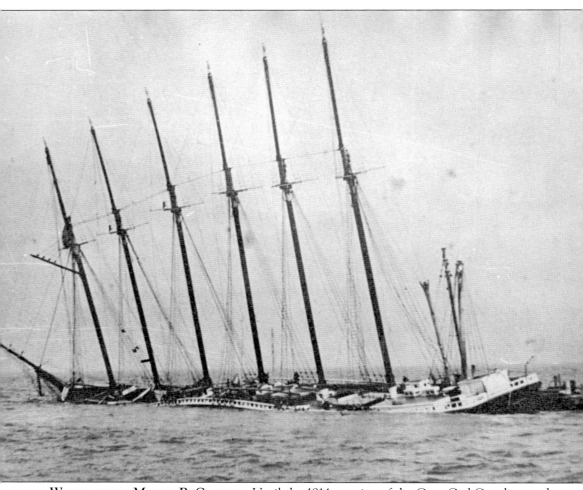

WRECK OF THE *MERTIE* B. CROWLEY. Until the 1914 opening of the Cape Cod Canal created a shortcut between the two ports, virtually all ship traffic between New York, Boston, and points beyond—tens of thousands of ships a year—traveled through Vineyard and Nantucket Sounds. Not all of them, however, made the passage safely. Off course because of a navigational error, the six-masted, 296-foot schooner *Mertie B. Crowley*, bound from Newport News, Virginia, to Boston with a cargo of coal, ran aground on the Wasque shoals, off the southeast corner of Chappaquiddick, on the night of January 23, 1910. Stuck fast on the submerged sandbar and battered by waves, the ship began to break up, forcing the crew to climb into the rigging and await rescue. When word reached Edgartown, Capt. Levi Jackson and his crew cast off in their 32-foot fishing boat, *Priscilla*, and—after hours fighting wind, waves, and near-freezing temperatures—came within sight of the stricken schooner. While Jackson held the *Priscilla* in position alongside the wreck, his crew rowed back and forth between the vessels in fishing dories, rescuing all 15 aboard the *Crowley*.

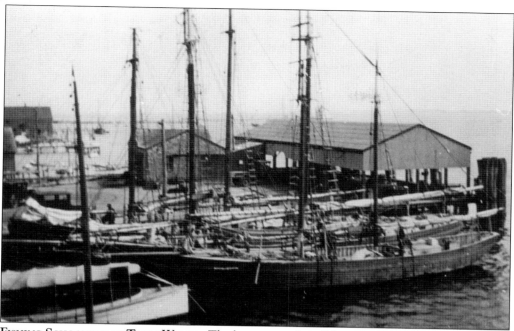

FISHING SCHOONERS AT TOWN WHARF. The largest vessels in Edgartown's fishing fleet, schooners like the *Hazel M. Jackson* were capable of trips lasting weeks rather than days, sailing to the Grand Banks east of Newfoundland for cod. After selling their catch on the mainland, they returned home to Edgartown for rest, repairs, and resupply before starting the cycle again.

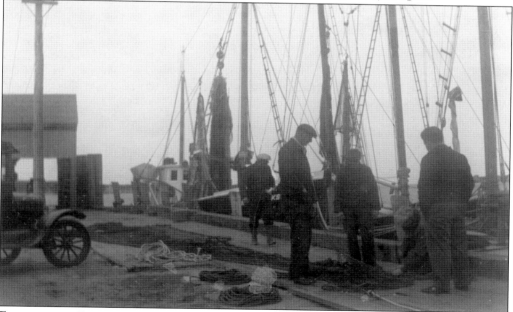

FISHERMEN ON DECK. Gasoline and diesel engines were ubiquitous among the Edgartown fishing fleet by 1940, when this photograph was taken, but vessels like the *Liberty* and the *Annie M. Jackson* were still rigged for sail. On the dock (from left to right), Claude Wagner, Harry Norton, and Charlie Meuser of the *Liberty* confer with Rip Bettencourt.

SMALL CRAFT IN HARBOR. Small craft designed for relatively sheltered waters are part of every working waterfront, but they were particularly common in Edgartown. Moored to private piers, pulled up onto beaches, or tethered to offshore stakes, they provided platforms for commercial and sport fishing, access to larger vessels, and access to outlying areas like Katama Bay and Cape Poge.

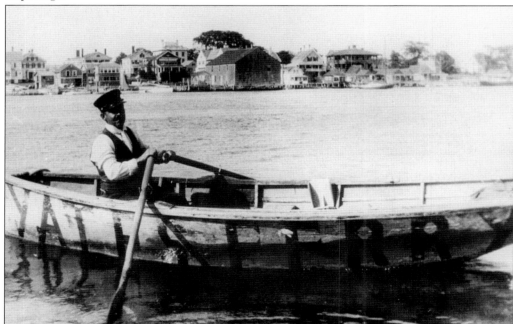

YATES'S CHAPPAQUIDDICK FERRY. James H. "Jimmy" Yates operated the Chappaquiddick ferry service from 1920 to 1929, his oar-powered skiff an anachronism in an age of motor-driven launches. He reveled in his eccentricity—wearing a brass-buttoned serge vest, a watch chain, a sunflower in his lapel, and a cap badge reading "Edgartown Ferryman #241"—but residents of Chappaquiddick found the slow speed and nonexistent cargo capacity of the skiff maddening.

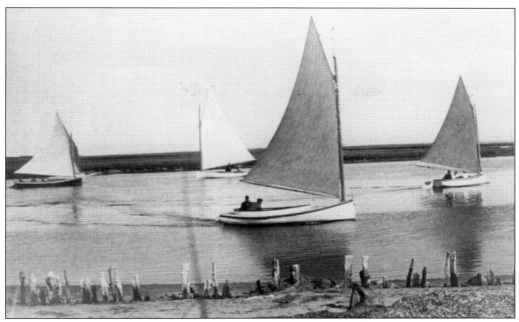

CATBOATS UNDER SAIL. Catboats—broad relative to their length and carrying a single, large, gaff-rigged sail on a mast set just behind the bow—were, like schooners, working vessels in which grace and beauty deferred to functionality. Ubiquitous in Edgartown during the first half of the 20th century, they were the pickup trucks of the waterfront: rugged, versatile, and indispensable.

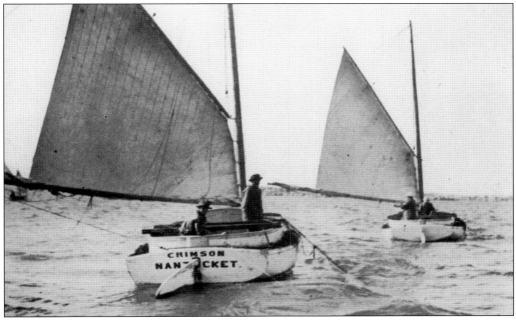

CATBOATS FISHING. The qualities that defined catboats gave them power, stability, and the ability to work in shallow waters that would ground a more conventional boat. These qualities, along with their capacious open cockpits, made them ideal for hauling cargo, pulling nets, and—as shown here in 1910—dragging for scallops. (Courtesy of the Massachusetts State Library.)

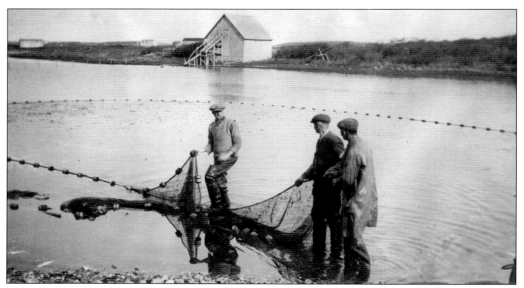

MATTAKESET: HANDLING NETS. One of Edgartown's most lucrative fisheries of the early 1900s, herring, barely required the use of boats at all. It worked by setting nets—held here by (from left to right) Harry B. and Edwin T. Smith and Albert Vincent—in the path of herring migrating through Mattakeset Creek from Edgartown Great Pond to Katama Bay. The four photographs on these pages date from the early 1920s.

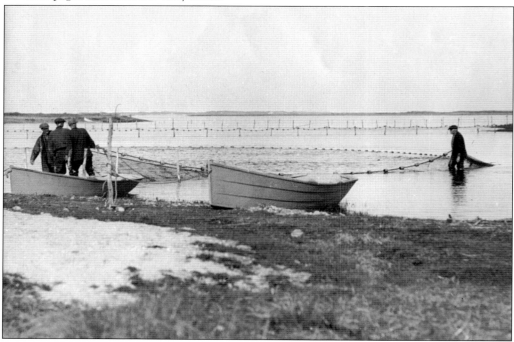

MATTAKESET: CLOSING THE TRAP. Wading into the shallows, herring fishermen (from left to right) Harry Smith, Edwin Smith, and Clarence Collins, assisted by Charles Earle (far right), prepare to tighten the net, drawing the fish toward shore. Floats hold the upper edge of the net, and lead weights keep the lower edge on the bottom.

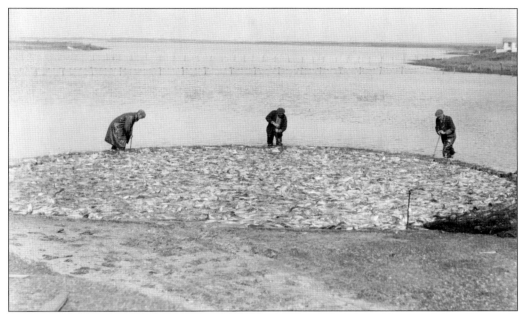

MATTAKESET: BRINGING IN THE CATCH. Drawing the net toward shore like a mesh bag filled with fish concentrates the catch and makes it easier to handle. Trap fishing, widely practiced off the beaches of West Tisbury, Chilmark, and the Elizabeth Islands in the early 1900s, used different equipment to achieve a similar result.

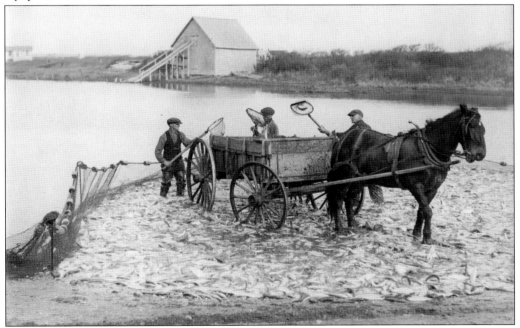

MATTAKESET: LOADING FISH. Transferred to the back of a waiting wagon with long-handled dip nets, the herring were taken by road to fish markets on the Edgartown waterfront. There, they were weighed, packed in barrels, and shipped to waiting customers, on-island or off-, for use as food or fertilizer.

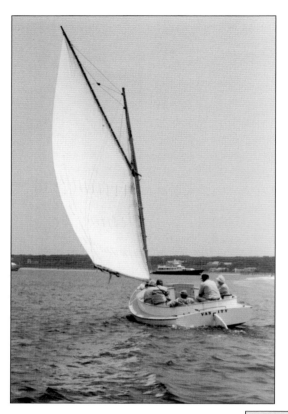

MANUEL SWARTZ ROBERTS, BOAT BUILDER. The small craft that filled Edgartown harbor were overwhelmingly built by local craftsmen like Manuel Swartz Roberts, the son of Portuguese emigrants from the Azores, who became Edgartown's acknowledged master of the catboat. The 21-foot *Vanity*, which he built for local fisherman Oscar Pease in 1928, is now a floating exhibit at the Martha's Vineyard Museum.

WATERFRONT WORKSHOP. "Man'l Swar'z" (as he was familiarly known) kept his workshop in an oddly shaped building opposite the Town Wharf, now the Old Sculpin Gallery. As the demand for wooden workboats faded, he turned his hand to fine furniture, some of which found its way into summer homes that, as a journeyman carpenter at the turn of the century, he had helped to build.

KATAMA-CLASS SLOOP. The growing popularity of recreational sailing in the 1920s and 1930s led to a profusion of specialized local designs like the Katama, shown here. Built by local craftsmen, like the workboats with which they shared the waterfront, they were superbly adapted to local conditions but hard to sell in other harbors—even those just a few miles away. (Photograph by Edith Blake.)

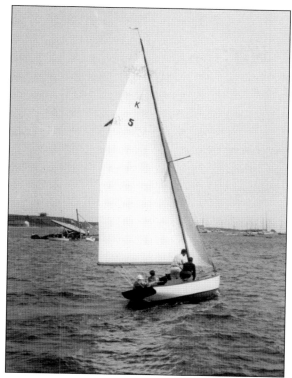

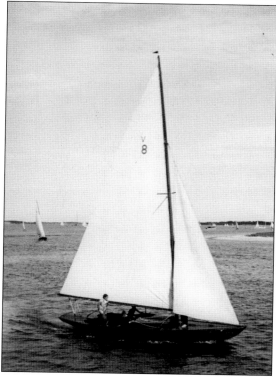

INTERCLUB-CLASS SLOOP. The Vineyard Sound Interclub, designed in 1928, was a deliberate attempt to create a regional class of boats in which sailors from the Vineyard Haven, Edgartown, and Nantucket Yacht Clubs could compete on even terms. A graceful 28-foot design suitable for day-sailing and weekend cruises, it enjoyed modest popularity as late as the mid-1950s. (Photograph by Edith Blake.)

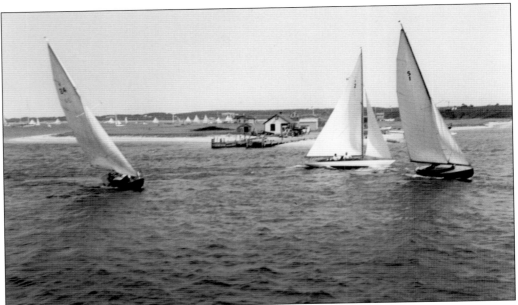

EDGARTOWN REGATTA PARTICIPANTS. The Edgartown Regatta, first staged by the Edgartown Yacht Club in 1924, included handicap racing for large cruising boats and one-design racing (in which variations between boats of a given class are kept to a minimum) for a variety of locally popular classes. It became an increasingly popular annual event, introducing recreational sailors from up and down the East Coast to Edgartown.

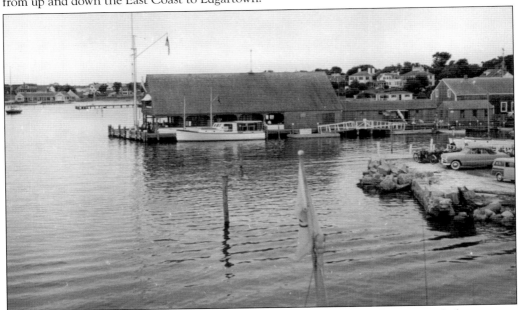

A NEW CLUBHOUSE. Commodore Elmer Jared Bliss, grandson of Edgartown whaling master Jared Fisher, arranged the purchase of Osborn's Wharf for the yacht club in 1926 and underwrote the construction of a new wooden pier. The new clubhouse, shown here in the early 1950s, was completed in 1928. Its opening marked, in retrospect, the symbolic turning point of Edgartown's transformation into a summer resort.

Six

LEARNING TO BE MODERN
1920–1945

In the quarter-century between the end of the First World War and the end of the Second, Martha's Vineyard straddled—not always comfortably—the boundary between tradition and modernity. Automobiles came to the island in growing numbers, but ferries were not yet designed to accommodate them easily and paved roads were not yet a given. The iceman and the ice box coexisted with the refrigerator, the ox cart with the truck, and kerosene lamps with electricity.

Some of the changes that transformed Edgartown in the decades between the world wars were purely practical. The consolidation of Edgartown's public schools into a single building offered students better facilities and the town economies of scale. The automation of the Edgartown and Cape Poge lighthouses lowered costs, increased reliability, and—in the latter case—eliminated the need for a keeper at a hardship posting known for its grinding loneliness.

Other changes were aspirational. Henry Beetle Hough began to remake the *Vineyard Gazette* within months of becoming editor, driven by a conviction that by saving labor, more modern equipment would make for a better paper. The Dukes County Historical Society, founded in 1922, began its life with no collections, no library, and no permanent home. Within a decade, it had acquired all three. The residents of Chappaquiddick who lobbied for a bridge to the remainder of the Vineyard had less success but shared in the era's conviction that change, thoughtfully undertaken, was worthwhile.

The three defining events of the era, however, were beyond anyone's control: hurricanes battered the Edgartown waterfront in 1938 and 1944, damaging larger buildings, demolishing smaller ones, and sinking or beaching scores of boats. Between the two storms, the outbreak of war brought hundreds of servicemen to Edgartown. Naval aviators practiced bombing and gunnery over South Beach and carrier landings at a newly built airfield in the state forest.

Edgartown emerged from the interwar and wartime decades visibly changed and poised for the still-greater changes that would come with peacetime.

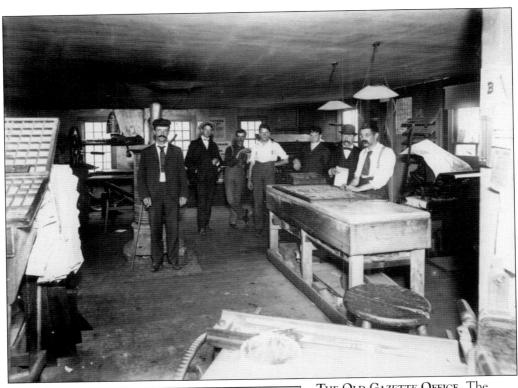

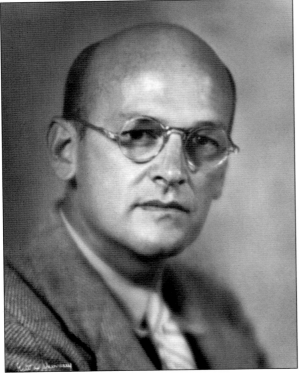

THE OLD GAZETTE OFFICE. The *Vineyard Gazette*, midway through its eighth decade of publication in 1920, had changed relatively little in that time. Charles Marchant, editor-publisher since 1888, turned out an eight-page weekly edition using hand-set type and a hand-turned press in rooms above a corner grocery store. Ready to retire, Marchant sold the paper to George A. Hough, managing editor of the *New Bedford Evening Standard.*

THE NEW EDITOR. Hough intended the paper as a wedding present for his son Henry Beetle Hough, a recent graduate of Columbia University who had won a special Pulitzer Prize while still a student. Henry, who had Vineyard ties through both parents and had spent childhood summers in West Tisbury, made the *Gazette* his career and became the unofficial poet laureate of the island. (Photograph by Editta Sherman.)

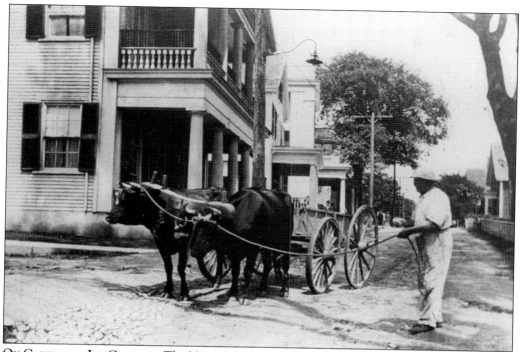

OX CARTS AND ICE CUTTERS. The Vineyard to which Henry Beetle Hough and Elizabeth Bowie Hough moved in 1920 had, like the newspaper they took over, one foot firmly planted in the past. There had been automobiles on the island for 20 years, electricity for more than 30, and telephone service for nearly 50, but men still harvested ice from frozen ponds each winter, and ox carts were still in regular use (two decades later, a small item in the *Gazette* would report the arrest of a local man for operating one while intoxicated). Until decade's end, at least one of the steamers from the mainland would be driven by paddlewheels, and Chappaquiddick's lifeline to Edgartown would be a man with a pair of oars.

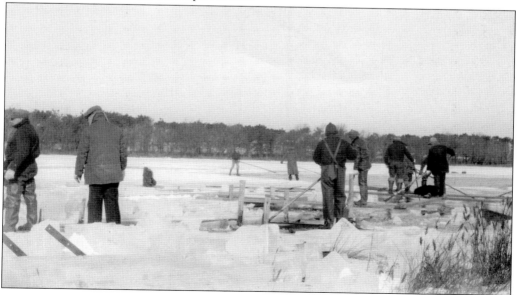

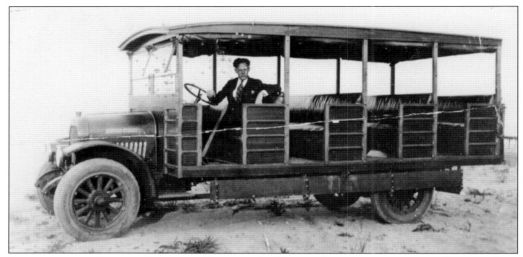

STEAMERS AND SERVICE STATIONS. Even on the Vineyard, modernity was rapidly overtaking tradition as the 1920s began to unfold, much of it driven by the ever-growing role of automobiles in Americans' everyday lives. The *Martha's Vineyard*, the first island steamer specifically designed to carry them, entered service in 1923. When she docked at Oak Bluffs, a bus operated by brothers Ernest and Luther Sibley was there to whisk Edgartown-bound passengers to their homes and hotels. The Sibleys also operated a capacious garage downtown on Kelley Street where cars could be rented, serviced, and (if need be) repaired.

THE FIRST LINOTYPE. Determined to modernize the *Gazette*, Henry Beetle Hough bought a used Linotype machine within months of becoming editor. The machine cast type from molten metal as the operator tapped out the text on a typewriter-like keyboard. Far faster than setting type by hand, the machine would, Hough promised readers, free up "a great fund of energy which will be devoted to improving the *Gazette*."

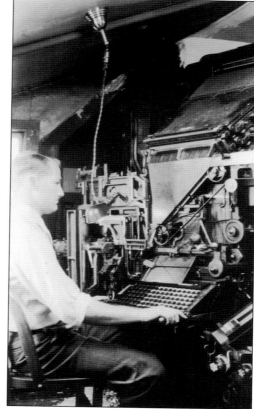

THE GAZETTE ON SUMMER STREET. Hough's purchase of the Linotype was followed, in rapid succession, by two other gambles on the future. The first was to move the paper's offices to a colonial-era house at 34 South Summer Street in 1922. The second was to replace the paper's aging, hand-cranked press with a motor-driven one that printed both sides of a sheet at once.

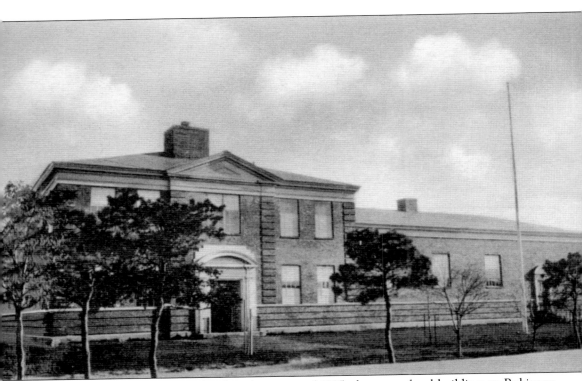

EDGARTOWN SCHOOL. Completed in the spring of 1925, the new school building on Robinson Road was designed to gather students in grades one through twelve under the same roof for the first time in Edgartown history. Graduation exercises for the 14 members of the class of 1925 were held there soon after the building opened, and Principal Walter Grenall welcomed 246 students (58 of them in the high school) at the beginning of the new school year in September. The 11 students of the class of 1926, who graduated the following spring, became the first to complete an entire year at the school, and the class of 1937 was the first to spend their entire careers there. Among the new building's amenities was a modern gymnasium, where the boys' and girls' basketball teams faced off against island rivals Tisbury and Oak Bluffs.

FOREST FIRE ENGINE. The woods and grasslands to the west of Edgartown village—declared "wasteland" by colonial-era settlers and largely untouched as a result—had a history of severe forest fires: 16 burned more than 1,000 acres between 1867 and 1929. This led the Edgartown Fire Department to acquire this specialized truck for fighting forest fires in 1930.

THE HEATH HEN. Aggressive fire management and the intervention by wildlife biologists failed to save the endangered heath hen: a once-plentiful species critically endangered even before a 1910 fire burned over much of the reserve (now, much expanded, the state forest) set aside to protect it. "Booming Ben," the last known heath hen, died in 1932, and the species was declared extinct in 1938.

THE DUKES COUNTY HISTORICAL SOCIETY. Founded in 1922 and incorporated in 1923, the Dukes County Historical Society (DCHS) set out to collect, preserve, and exhibit artifacts and documents that illustrated the history of Martha's Vineyard and the Elizabeth Islands. Meeting in libraries, churches, and private homes, the society published a series of historical pamphlets and acquired substantial collections related to colonial, Revolutionary, and maritime history.

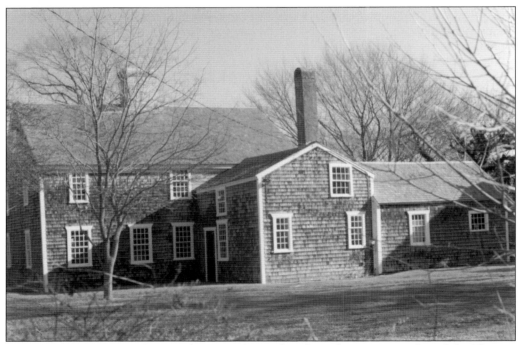

DCHS AT THE COOKE HOUSE. Eight years after its founding, the society purchased the Thomas Cooke House (built in 1740) to serve as a permanent headquarters, storage and exhibit space, and an exhibit in its own right. It remained the society's only facility until after World War II.

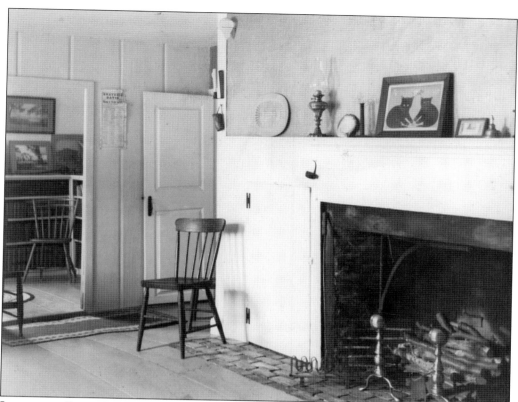

INSIDE THE COOKE HOUSE. The Cooke House's many rooms enabled the society to display artifacts from its collection—furnishings, dishes, textiles, and paintings—in thematically or chronologically related groups. At various times, one room recreated the parlor of a 19th-century captain's home, another simulated the customs office of Thomas Cooke Jr., and a third displayed artifacts of the Adams sisters of Chilmark.

SURFBOARDS FROM HAWAII. Larger objects, like these surfboards brought back from a voyage to Hawaii and pieces of wreckage from the *City of Columbus*, posed greater challenges. Virtually impossible to display effectively in the Cooke House, they remained in storage until new display space was constructed on the land adjacent to the Cooke House, acquired by the society in 1949.

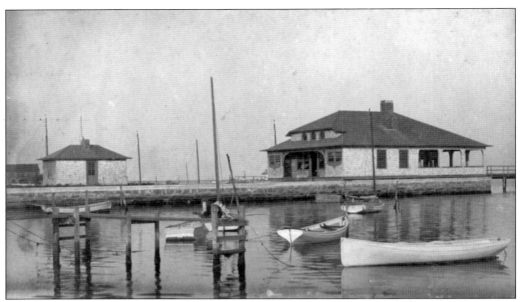

EDGARTOWN READING ROOM. Originally built as a boathouse for one of the summer homes on South Water Street, the Edgartown Reading Room was transformed in 1934 into a private club. The stone-walled pier on which it sits was once Collins' Wharf, built a century earlier to serve whaling ships.

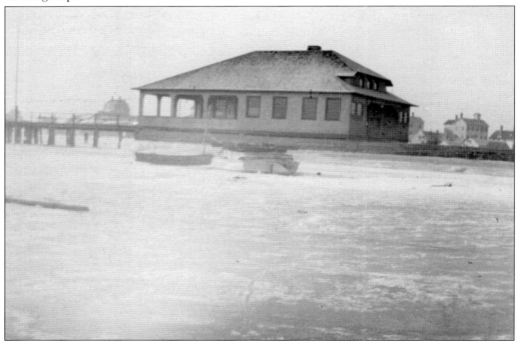

EDGARTOWN READING ROOM. Despite its name, the Reading Room was conceived primarily as a site for its members to eat, drink, and socialize. A widely repeated (and possibly apocryphal) story states that a founding member, feeling that a reading room should have books, donated his copy of the Edgartown phone directory as the first volume in the collection.

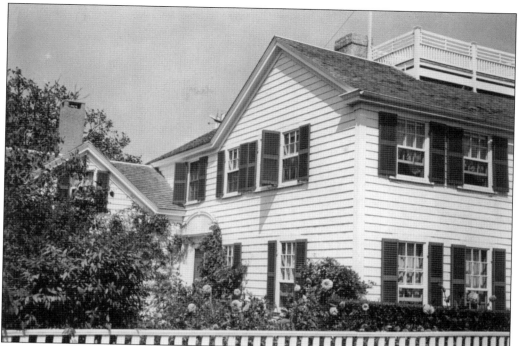

EMILY POST HOUSE. Etiquette expert Emily Post was one of many celebrities who discovered Martha's Vineyard in the 1920s and 1930s. She summered at this Fuller Street house from 1927 until her death in 1960, describing Edgartown in a 1933 *Vogue* interview as "the haven of delectable tranquility that all my life I have been searching for."

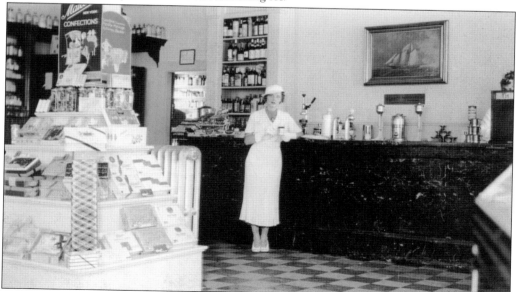

MARY ARBENZ AT THE DRUGSTORE. Broadway actress Mary Arbenz poses for a photograph at the soda fountain counter of an unnamed Edgartown drugstore in the summer of 1934. She and fellow actor Leslie Denison spent that summer performing at the Rice Playhouse summer repertory theater in Oak Bluffs.

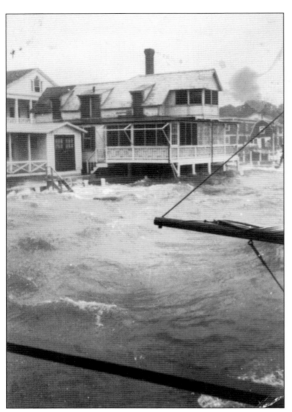

HURRICANE WAVES. The Great New England Hurricane (they were not given names until 1953) struck the Vineyard with virtually no warning on September 21, 1938. Storm waves flooded the Edgartown waterfront, washing away fishing shacks and boathouses, and winds approaching 100 miles per hour ripped boats from their moorings and swept them out to sea.

YACHT CLUB SUBMERGED, 1938. The hurricane's massive storm surge, driven through the opening in Norton Point Beach and up Katama Bay, flooded the Edgartown waterfront. Water rose "halfway to the eaves" of the Edgartown Yacht Club, the *Gazette* reported in its post-storm edition of September 23, and "there were whitecaps in Wilson Crosby's yard."

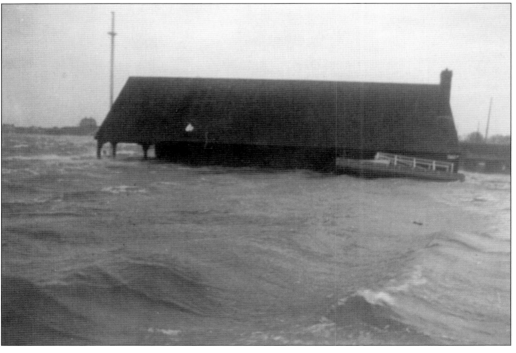

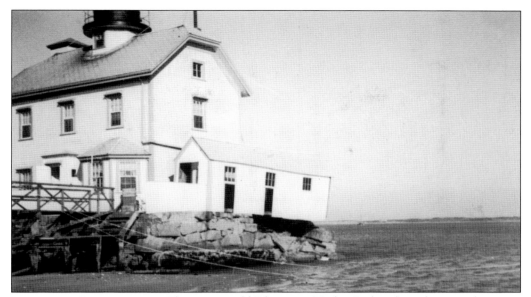

LIGHTHOUSE DAMAGE, 1938. The century-old Edgartown Harbor Light—beset by rot and vermin, and slated for replacement by the Coast Guard—survived largely intact, but the stone island on which it stood was damaged. Seven or eight boats, including the new motorized ferry that had served Chappaquiddick since 1934, were trapped against the lighthouse's footbridge and battered to pieces by the waves.

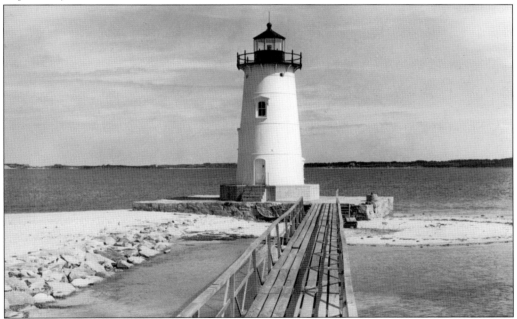

THE NEW EDGARTOWN LIGHT, 1939. Faced with a storm of protest from residents, given form and voice by Henry Beetle Hough in the *Gazette*, the Coast Guard abandoned plans to replace the old lighthouse with a steel-skeleton tower. A cast-iron lighthouse from Ipswich, no longer needed at its original site, was substituted instead and erected on the same stone island that had held the old wooden one.

GIRLS' BASKETBALL, 1938. Football was all but unknown on the Vineyard before 1945; high-school basketball fired sports fans' passions and teenagers' dreams of glory. The 1938 Edgartown High girls' team included, from left to right, (first row) Adeline Hall, Betty Simpson, captain Dorothy Scott, Margaret Stuhler, Shirley Black, and Amy Look; (second row) G. Viera, Catherine Perry, Hilda Benefit, Ruthy Waters, and E. Jackson; (third row) coach Ester Shirt, Yvonne Berube, Sheila Waters, Elaine Dietz, Dorothy Stuhler, and Janice Elliot.

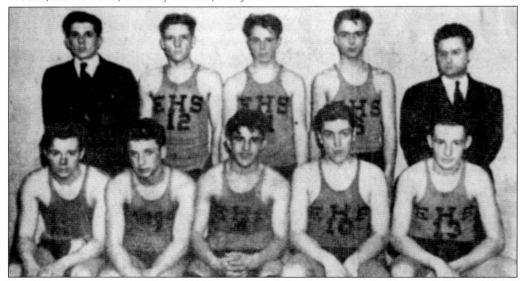

BOYS' BASKETBALL, 1941. The 1941 Edgartown High boys' team won the Vineyard Championship and the Cape and Islands Championship. Longtime fans judged it to be the best team in the school's history. It included, from left to right, (first row) Eldon Willoughby, Sam Leighton, Charlie Mello, Bud Brown, and Bob Morgan; (second row) manager Francis Perry, Elmer Porter, Duncan McBride, Danny Gaines, and coach Joe Robichau.

COUNTRY EDITOR. First published in 1940, Henry Beetle Hough's memoir *Country Editor* recounted his first 20 years at the *Gazette*. His affectionate portrait of small-town life caught the reading public's fancy in an era of rapid industrialization and looming war fears, and the book sold well, bringing Hough unexpected fame and the Vineyard new prominence.

Country Editor

By
HENRY BEETLE HOUGH

1940
Doubleday, Doran & Company, Inc.
NEW YORK

CAPE POGE LIGHT. The lighthouse at Cape Poge was automated in 1943 (as the new Edgartown Harbor Light had been in 1939), ending the loneliest job on the island. The 1880 keeper's house was left intact and, for the duration of the war, housed the Coast Guard shore patrols who kept watch for enemy saboteurs like those captured on Long Island in June 1942.

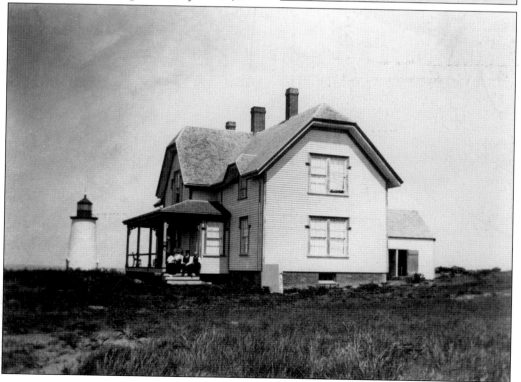

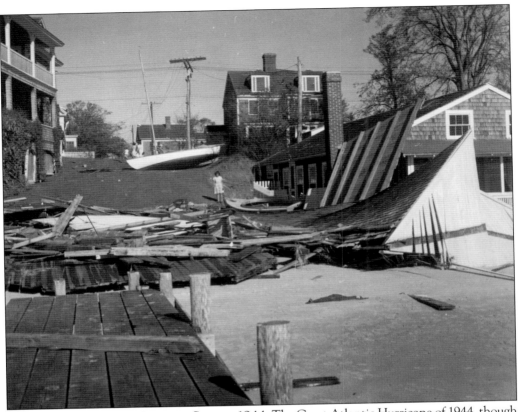

HURRICANE DAMAGE ON DAGGETT STREET, 1944. The Great Atlantic Hurricane of 1944, though less remembered than the 1938 hurricane, struck the Vineyard with a direct rather than a glancing blow, doing more extensive property damage and killing 14. The damage seen here—jumbled roofs and a boat deposited at the edge of North Water Street—illustrates the combined power of the storm's wind and waves.

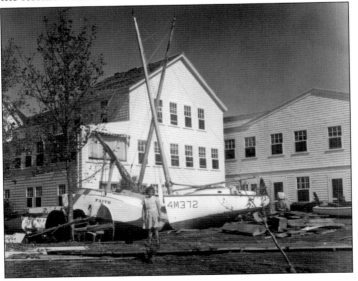

CATBOATS ON THE LAWN, 1944. Like the 1938 hurricane, the 1944 storm highlighted Edgartown's vulnerability to storm surge, the coastal flooding caused by hurricanes. These catboats, plucked from their harbor moorings by the rising water, were carried nearly a block inland and deposited on the lawn of the Kelley House.

Manxman Ashore, 1944. The largest vessel sent ashore by the hurricane was the 117-foot steel-hulled cruising yawl *Manxman*, sailed by a paid crew under the command of Samuel B. Norton of Edgartown. She came to rest between Chadwick's and Osborn's Wharves, pinning the fishing boat *Priscilla V.* against the beach.

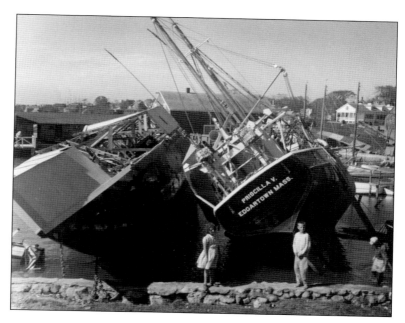

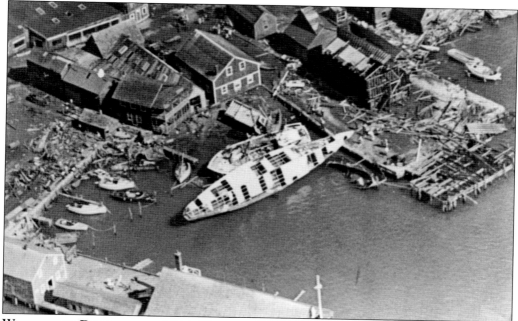

Waterfront Devastation, 1944. This aerial view of the harbor shore, taken the day after the storm, reveals the scope of the destruction. *Manxman* and *Priscilla V.* are in the center, and Chadwick's Wharf, strewn with debris and dominated by the now-roofless coal shed, is at upper right.

NAVAL AIR STATION. Bulldozed out of the state forest on the far western edge of Edgartown, the Martha's Vineyard Naval Auxiliary Air Facility (as it was officially known) was completed in 1942 at a cost of $2 million. A satellite of the new naval air station at Quonset Point, Rhode Island, it was used to train naval aviators for carrier landings, night interception missions, and antisubmarine patrols off the Atlantic coast. Pilots from Quonset Point and elsewhere, practicing bombing and gunnery on Navy ranges at Chappaquiddick and Katama, used it as a backup landing site in case of inclement weather or mechanical trouble. At the height of its operations, it served as a base for 68 naval aircraft, mostly Grumman Avenger torpedo bombers.

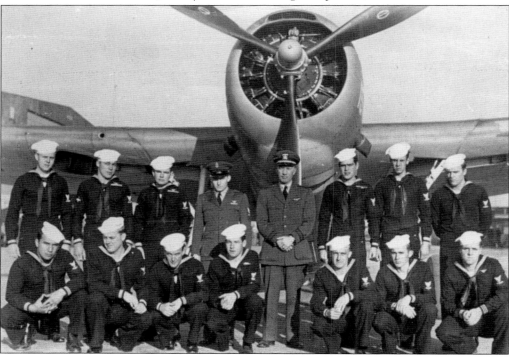

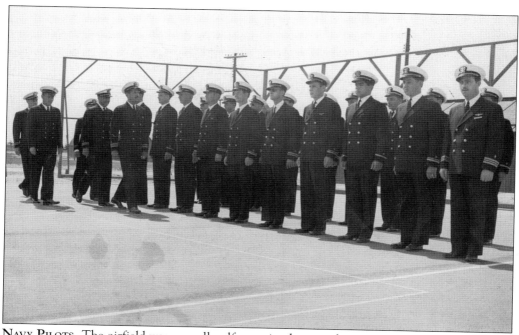

NAVY PILOTS. The airfield was a small, self-contained town whose peak population of 784 was larger than that of West Tisbury, Chilmark, and Gay Head combined. The aviators—all officers, per Navy policy—received the majority of the press's and public's attention, their wartime work tinged with glamour despite its deadly seriousness. They were outnumbered more than six to one, however, by the enlisted men who worked behind the scenes and beside the runways maintaining the aircraft, operating the control tower, and standing by the emergency equipment in case of a crash. Some assigned to the base were native Vineyarders or, like Lt. Henry Scott, summer residents; others returned after the war, some to vacation and others to settle down.

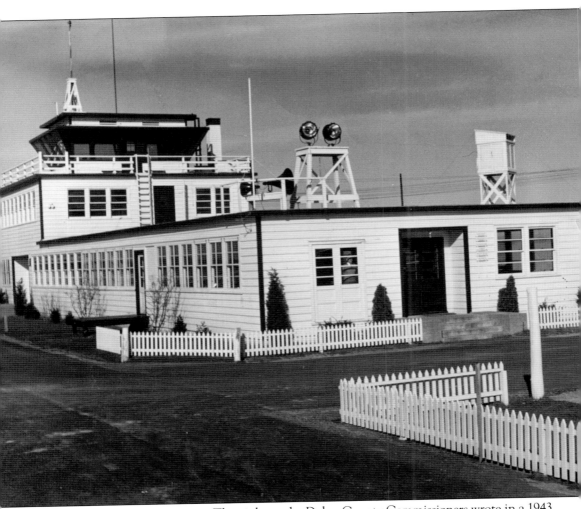

MARTHA'S VINEYARD AIRPORT. The air base, the Dukes County Commissioners wrote in a 1943 report on the facility, "will mean much to the future development of the town of Edgartown and the other municipalities of the county." And so it did. Seaplanes had been landing on island harbors since the 1920s, and there were grass-strip airfields at Katama and Oak Bluffs, but the new facility, with its state-of-the-art control tower and long, hard-surfaced runways, opened up the possibility of scheduled air service from the mainland. The first Northeast Airlines flights landed in August 1944, and by 1946, the base had been placed in caretaker status and turned over completely to civilian traffic. DC-3s from Boston touched down where Avengers once practiced carrier landings and taxied to the former base operations building—now the terminal—to unload the first in a new wave of island visitors. (Photograph by Frank W. Small.)

Seven

WELCOMING THE WORLD
1946–1975

The Vineyard changed profoundly in the decade after VJ Day, as old institutions faded into sepia-toned memory and new ones (now with another half-century or more gone by just as hallowed in middle-aged memories) emerged in their place. Ellsworth West, the last of the Vineyard whaling captains, died in 1949. Electricity reached Gay Head, the last town in Massachusetts without it, in 1952. Fishermen traded their catboats for diesel-powered draggers or skiffs with gasoline-powered outboards on their sterns, and yachtsmen edged away from wooden hulls and toward fiberglass ones.

"Being a summer resort had become a full-time job," historian Arthur Railton remarked of the postwar era in the final line of his book *The Story of Martha's Vineyard*, but what it meant to be a summer resort was also changing. Tourists were more likely to come by car than train and to stay for days rather than weeks (let alone months). The sprawling Victorian resort hotels were demolished or modified beyond recognition, and two-story motels took their place. Eager to extend the tourist season, the Martha's Vineyard Chamber of Commerce organized the first Striped Bass Derby in the fall of 1946. It would succeed beyond the chamber's wildest dreams.

Edgartown, more developed than Gay Head and less dependent on casual tourism than Oak Bluffs, felt the changes less sharply than other parts of the island, but it felt them nonetheless. For all that they were gradual, however, the changes were substantial. By the late 1960s and early 1970s, Edgartown would see changes of a nature and a scope that no other island town had dreamed of.

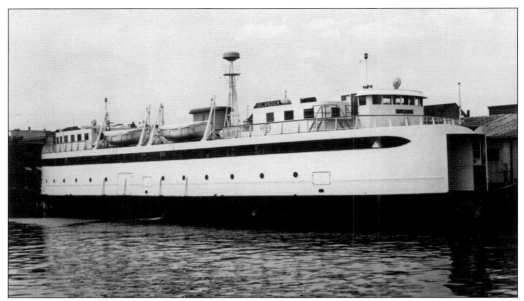

ISLANDER. On the Vineyard as on the mainland, the automobile transformed tourism in the 1950s, increasing demand for paved roads, ample parking lots, and clear signage. The *Islander*, the first purpose-built island ferry with a double-ended design that allowed for the rapid loading and unloading of cars and large trucks, entered service in 1950.

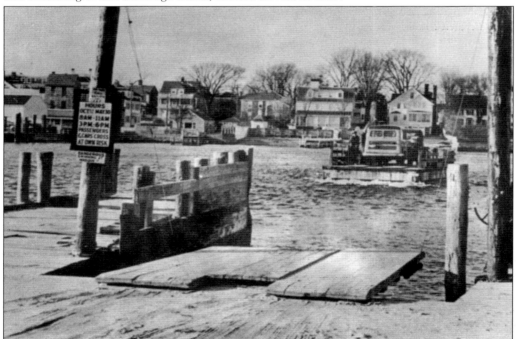

ON TIME. The first motor-driven, barge-style ferry to Chappaquiddick went into service in 1934, but a larger replacement, capable of carrying an additional car, was delivered in 1948. It was christened *On Time*—in the absence of a published schedule it was, by definition, always "on time"—and the name was passed on to every subsequent Chappaquiddick ferry.

CLAYTON HOYLE. Bass Derby competitors like Clayton Hoyle, shown here with a vintage wooden reel that would have drawn second looks even in 1946, were a breed apart from summer tourists. Intensely focused on a single activity, they pursued it on the island's remote margins, at sites like Norton Point, Wasque, Katama, and Chappaquiddick's East Beach.

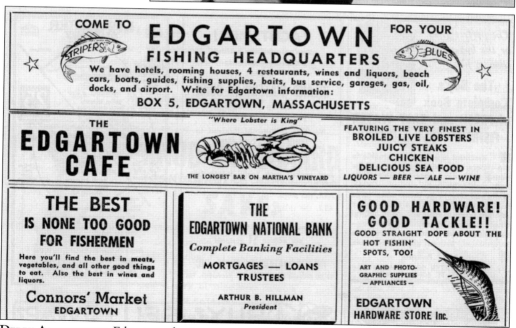

COME TO **EDGARTOWN** FOR YOUR

STRIPERS ☆ **FISHING HEADQUARTERS** ☆ BLUES

We have hotels, rooming houses, 4 restaurants, wines and liquors, beach cars, boats, guides, fishing supplies, baits, bus service, garages, gas, oil, docks, and airport. Write for Edgartown information:

BOX 5, EDGARTOWN, MASSACHUSETTS

THE
EDGARTOWN CAFE

"Where Lobster is King"

THE LONGEST BAR ON MARTHA'S VINEYARD

FEATURING THE VERY FINEST IN
**BROILED LIVE LOBSTERS
JUICY STEAKS
CHICKEN
DELICIOUS SEA FOOD**
LIQUORS — BEER — ALE — WINE

THE BEST
IS NONE TOO GOOD FOR FISHERMEN

Here you'll find the best in meats, vegetables, and all other good things to eat. Also the best in wines and liquors.

Connors' Market
EDGARTOWN

THE
EDGARTOWN NATIONAL BANK

Complete Banking Facilities

**MORTGAGES — LOANS
TRUSTEES**

ARTHUR B. HILLMAN
President

GOOD HARDWARE!
GOOD TACKLE!!

GOOD STRAIGHT DOPE ABOUT THE HOT FISHIN' SPOTS, TOO!

ART AND PHOTO-GRAPHIC SUPPLIES — APPLIANCES —

EDGARTOWN HARDWARE STORE Inc.

DERBY ADVERTISING. Edgartown businesses—even those not directly connected to sport fishing—recognized the potential offseason windfall that the Bass Derby represented. These advertisements from the fall 1952 issue of *Saltwater Sportsman* reassured visiting fishermen that all their needs—food, drink, rooms, gear, and information—could be met in Edgartown village.

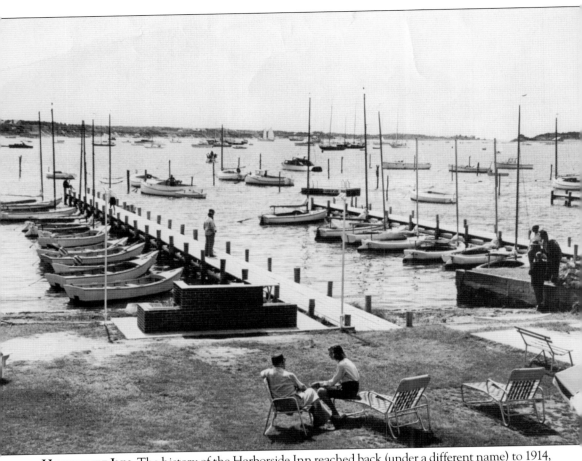

Harborside Inn. The history of the Harborside Inn reached back (under a different name) to 1914, when Antone Prada Jr. bought a South Water Street boardinghouse (page 29) and transformed it into a hotel. Expanded in subsequent decades by the purchase of several former whaling captains' houses, it underwent a wholesale transformation after World War II at the hands of general manager Arthur Young. Anticipating that much of the inn's postwar business would be middle-class tourists with limited budgets, Young abandoned the then-standard American plan, in which the room rate included three meals a day in the hotel's dining room, for the European plan, in which a lower daily room rate covered the room only. The former dining room—located on the site of the 1905 Edgartown Yacht Club (page 57)—became a stand-alone restaurant catering to guests and casual visitors alike. Young also expanded the inn itself with a block of modern, motel-style rooms overlooking a lawn, outdoor pool, and piers where guests could rent sailboats and rowboats by the hour.

KATAMA SHORES MOTOR INN. The Katama Shores Motor Inn was the brainchild of Francis and Eleanor Atwood, who remodeled war-surplus Navy buildings into a two-story motel catering to the car-oriented tourists of the postwar era. Located at the end of the Katama Road, it offered an attached restaurant and cocktail lounge, ample parking, and easy access to the beach.

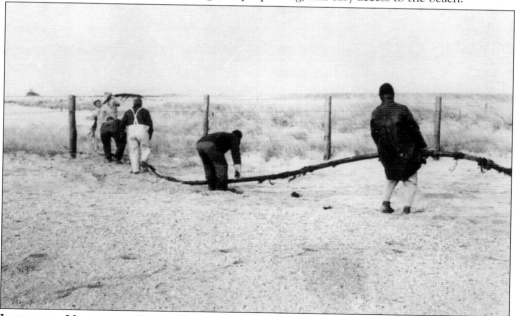

LAYING THE NANTUCKET CABLE. The postwar era brought a flurry of improvements to the island's infrastructure, including the expansion of electrical and telephone service and the paving and widening of roads. Among the projects was a new submarine cable from Katama to Nantucket laid by New England Telephone Company crews in the early 1950s.

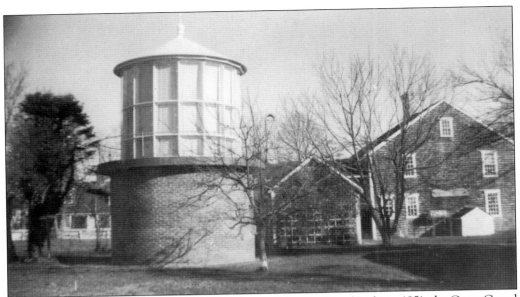

THE FRESNEL LENS. When electrical service reached the Gay Head Light in 1951, the Coast Guard announced plans to replace its kerosene-burning lamp and 1854 Fresnel lens with a high-intensity electrical beacon. The beehive-shaped Fresnel lens—1,004 precision-cut glass prisms mounted in iron frames—was transferred to the Dukes County Historical Society campus, where it was mounted in a replica of the lighthouse it had occupied for 96 years.

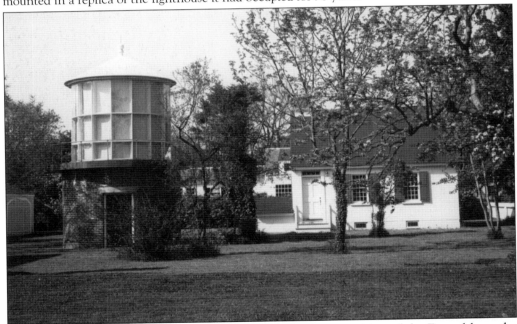

HISTORICAL SOCIETY LIBRARY. In 1954, two years after its acquisition of the Fresnel lens, the society added a small, stand-alone building adjacent to the lighthouse tower to house its growing collection of books and manuscripts. A 1978 addition to the left of the front door, used first as exhibit space and then as climate-controlled storage for the society's archives, doubled the library's size. (Photograph by Frank W. Small.)

HURRICANE CAROL, 1954. The third and fourth major hurricanes to hit the Vineyard in less than 20 years, Carol and Edna struck within 10 days of each other in September 1954. Lower Main Street is submerged and its sidewalks awash in this photograph taken at the height of the storm from a vantage point just below Water Street.

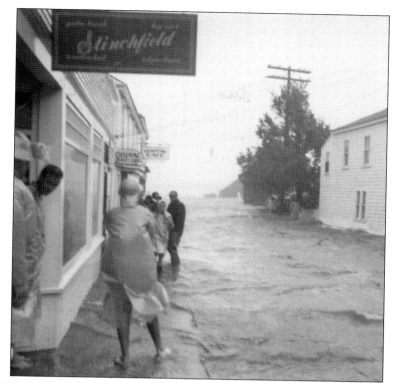

CAROL'S AFTERMATH, 1954. Floated out of the harbor on the storm surge and driven inland by wind and waves, a comically out-of-place fishing boat rests on an Edgartown sidewalk the day after Carol. The boat's final resting place, beside an elegantly lettered sign reading "No Parking, Please," adds a touch of levity to the storm's grim aftermath.

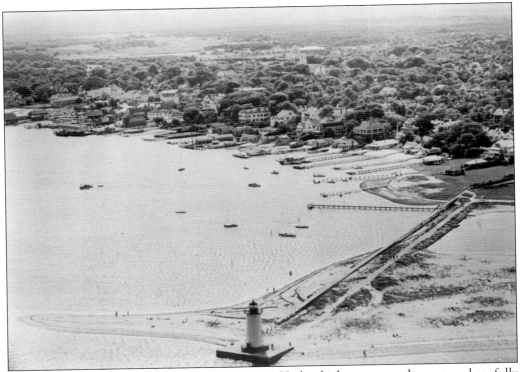

LIGHTHOUSE BEACH. The current (1939) Edgartown Harbor Light was erected on a stone base fully surrounded by water, but a postwar stone causeway, paralleling the existing wooden footbridge, caused sand to begin accumulating around the base of the light, forming what is now Lighthouse Beach. This aerial photograph shows the beach partially formed and the lighthouse's stone base still lapped by waves on its seaward side.

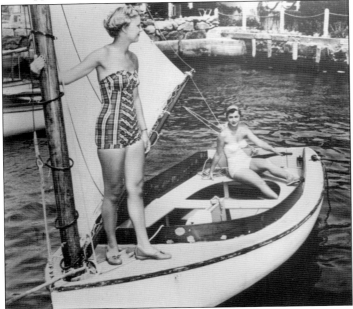

FUN-IN-THE-SUN TOURISM. The newly formed beach, publicly owned and minutes from town, became a popular tourist destination. It appealed to the active, sun- and sand-loving vacationers—sunbathers, small-boat sailors, and swimmers—whom the island courted in the 1950s and 1960s with images like this. (Courtesy of the Massachusetts Department of Commerce.)

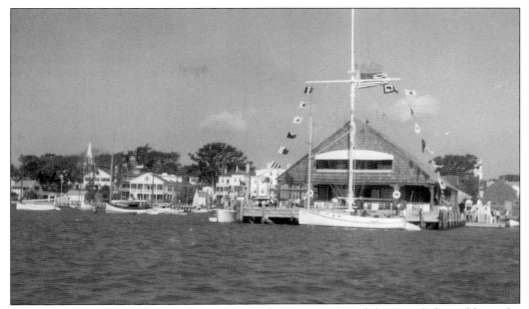

The Clubhouse on Osborn's Wharf. The Edgartown Yacht Club expanded steadily in the postwar era, balancing respect for tradition—its race committee wore navy blazers, "Edgartown red" trousers, and white yachting caps when overseeing the regatta—with enthusiasm for new racing classes and new technologies like fiberglass hulls and self-bailing cockpits.

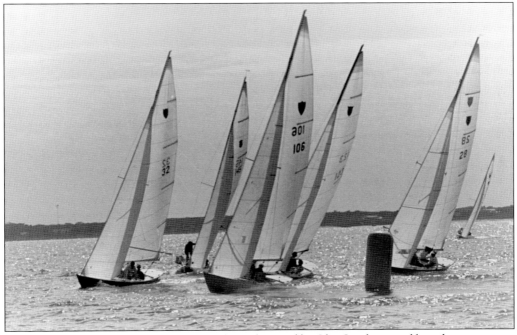

Shields Fleet. The 30-foot Shields-class sloop, designed by Olin Stephens and based on a concept by Cornelius Shields, became one of the yacht club's racing classes in 1967. The class remains popular, and in 2017, on the 50th anniversary of its introduction at the club, Edgartown hosted the Shields national championship. (Photograph by Edith Blake.)

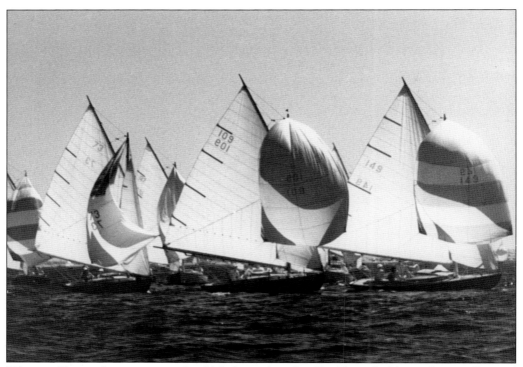

WIANNO FLEET. As conspicuously old-fashioned as the Shields is sleekly modern, gaff-rigged Wianno Seniors crossed Nantucket Sound—often in fleets numbering 20 or more—to sail in the Edgartown Regatta each July. A throwback to the prewar days of hyper-local racing classes named for the Cape Cod harbor where they originated, they remained active even after other such classes, including the Katama and the Edgartown 15, faded away.

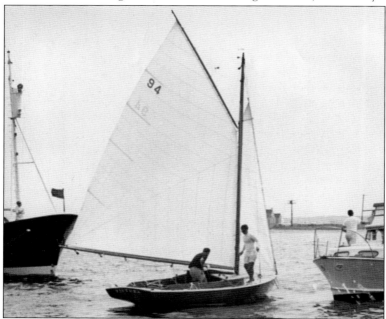

VICTURA. The most famous of all the Wianno Seniors, the Kennedy family's *Victura*, sailed in several postwar regattas, including one in 1947 with future president John F. Kennedy at the helm. On that visit, Kennedy stayed with two brothers and two sisters at Norah Fuller's guest house at 128 Main Street, later the Hob Knob Inn.

DERBY CONTESTANTS. The Bass Derby has, for many participants, traditionally been as much about friendship as fish. In this photograph from the 1950s, three local fishermen, (from left to right) Steve Gentle, Leo Convery, and Nelson Smith, show off the results of their late-night fishing expedition on an Edgartown pier.

OUT-OF-TOWN FISHERMAN. The first Bass Derby, in 1946, drew an astounding 1,000 contestants. Many were from the Vineyard, but those from off-island represented 29 states and at least one Canadian province. The derby's reach only expanded over time. The name and hometown of this participant in the 11th derby in 1957 is unrecorded, but his clothes suggest that he is, to use a 19th-century expression, "from away."

WAITING FOR A STRIKE. Winthrop B. "Sonny" Norton enjoys a contemplative moment while tending his lines somewhere on South Beach. The isolation the picture implies is probably an artfully framed illusion; if the bass or "blues" were running, other fishermen likely lined the beach to either side of his chosen spot.

THE FISHERMAN FROM BEACON HILL. Massachusetts lieutenant governor (and future cabinet secretary) Elliot Richardson took time off from state politics to participate in the 1965 derby. Here, dressed for the beach, he discusses the finer points of surf casting on South Beach with veteran Vineyard fisherman Dech Hathaway. (Photograph by Mosher Studios.)

THE OPEN DOOR CLUB. People of color were an established presence in Oak Bluffs by mid-century, but Edgartown remained almost exclusively white. African American domestics—servants who traveled to Edgartown with their employers—had nowhere to go on their time off (traditionally Thursday and Sunday afternoons and evenings), since the tacit segregation of the era meant that restaurants, dance halls, and beaches were closed to them. James and Edna Smith (pictured at right) opened their home to fellow domestics in 1939 under the name the Open Door Club. Members prepared and shared meals, talked, sang, and organized outings such as beach trips to Oak Bluffs. At its peak in the 1950s (below), the club had as many as 100 members.

NAACP, 1963. The Martha's Vineyard chapter of the NAACP was formed in mid-December 1963, spurred by the visits of Vineyard Haven minister Harry Bird and Edgartown physician Robert Nevin to Williamstown, North Carolina. Weeks later, the chapter played host to a visiting delegation from Williamstown, participating together in a service at the Whaling Church.

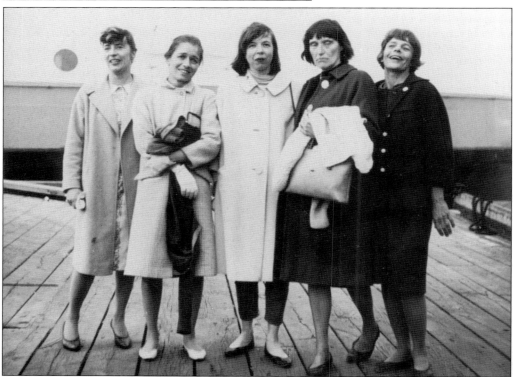

THE "VINEYARD FIVE." A group of five women from the Vineyard NAACP chapter—(from left to right) Polly Murphy, Nancy Hodgson, Peg Lilienthal, Virginia Mazer, and Nancy Smith—drove to Williamstown in the spring of 1964 to support civil rights protests there and were jailed overnight by local police. Returning to the island, they were hailed by friends and family as the "Vineyard Five."

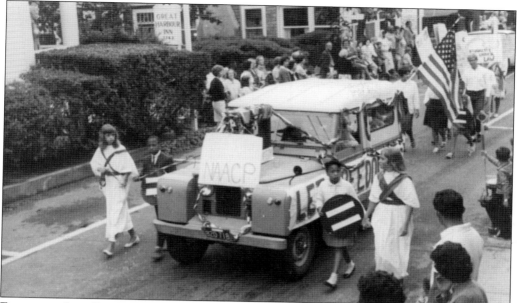

FOURTH OF JULY PARADE, 1964. A Land Rover decorated by the Vineyard NAACP passes the Kelley House during the town's 1964 Independence Day parade. The banner reading "Let Freedom Ring" and the black and white children walking hand-in-hand on either side, (from left to right) Deborah Mayhew, Tony Alleyne, Vanessa Alleyne, and Diane Powers, evoke Dr. Martin Luther King Jr.'s "I Have a Dream" speech, delivered the previous August.

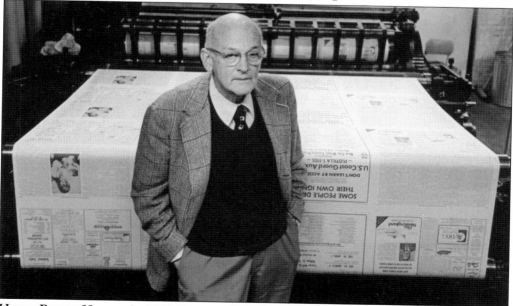

HENRY BEETLE HOUGH. In 1959, Henry and Elizabeth Hough used $7,500 from his non-*Gazette* writing to purchase Sheriff's Meadow, north of their home on Pierce Lane, in order to ensure that it would remain forever wild. The Sheriff's Meadow Foundation, which they formed to oversee it, developed into one of the Vineyard's premier conservation groups, and Henry Hough became one of the island's most articulate (and, to developers, exasperating) advocates for limits to growth.

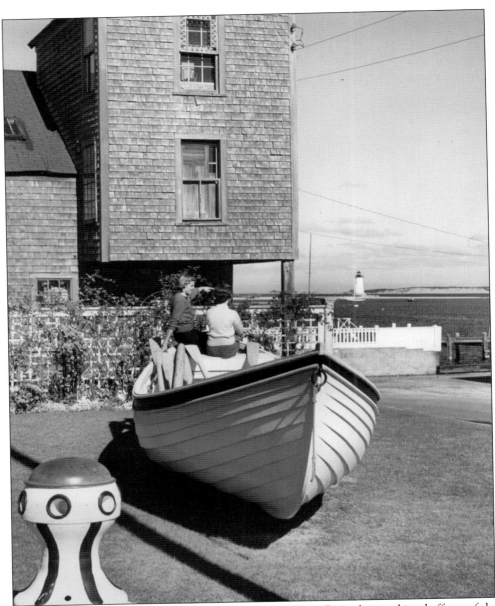

NAUTICAL RELICS. Dock Street, pictured in the mid-1960s, reflects the combined effects of three catastrophic hurricanes and a concerted effort by the town to make what was—to a degree—still a working waterfront a comfortable and appealing space for tourists. Manuel Swartz Roberts's boatbuilding shed, which he vacated and put up for sale shortly before his death, was repurposed largely intact as a gallery bearing its former inhabitant's affectionate nickname "the Old Sculpin." On a swath of grass next door, nautical relics painted glossy black and white—a capstan, a surfboat, and (behind the photographer) a try-pot salvaged from the deck of a whaleship—do for Edgartown's nautical history what the decommissioned armaments in Cannonball Park do for the Civil War. Across the street, just out of frame to the right, the Town Wharf sports a rooftop observation deck for tourists while still serving as a base of operations for the *On Time* and the town's dwindling commercial fishing fleet.

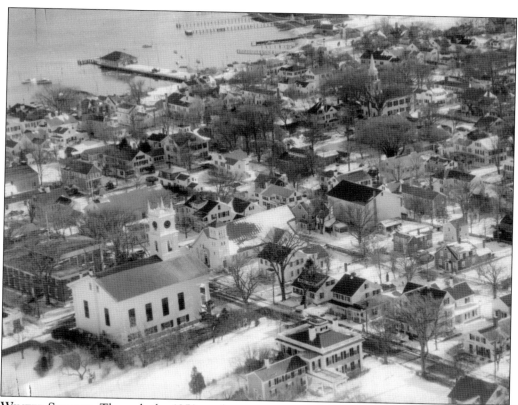

WINTER STREETS. Through the 1950s and 1960s, Edgartown in the offseason looked much as it does in this aerial photograph: a town seemingly all but deserted, with few cars and fewer people on the streets. The exuberant chaos of the Bass Derby aside, the "shoulder seasons" of late spring and early fall were not yet integrated into the summer resort economy.

CLOSED STORE. The abbreviated (by modern standards) tourist season meant that businesses catering to the summer crowds closed early in the fall and opened late in the spring. Main Street was still home to grocery, hardware, and drugstores, however, and so the atmosphere created by the transition from on- to off-season was quiet but not desolate.

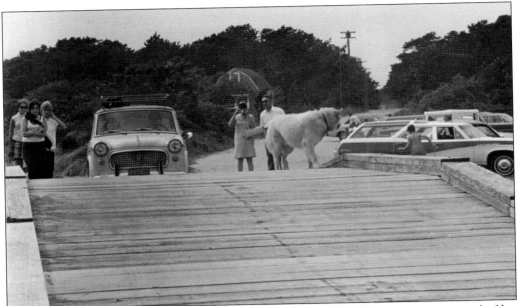

DIKE BRIDGE. The bridge on Chappaquiddick where Sen. Edward Kennedy lost control of his automobile and drove into the water on the night of July 18, 1969, became a macabre tourist attraction in the months and years that followed. This view from the Chappaquiddick side shows its angle to the road and lack of guardrails, contributing factors in the accident. (Photograph by Edith Blake.)

KENNEDY IN COURT. Flanked by state police officers, Kennedy leaves a hearing at the Dukes County Courthouse a week after the accident. Despite the death of his passenger, Mary Jo Kopechne, in the overturned, submerged vehicle, Kennedy was charged only with leaving the scene of an accident. Pleading guilty, he received the minimum sentence of two months in jail, which the judge suspended. (Photograph by Edith Blake.)

PRESS PLATFORM FOR THE KENNEDY INQUEST. The coroner's inquest into Mary Jo Kopechne's death—though held in early January 1970, during the quietest time of the island year—drew nationwide media attention. This temporary platform, erected opposite the courthouse on School Street, was designed to give photographers and camera crews a vantage point. (Photograph by Edith Blake.)

DISTRICT ATTORNEY EDMUND DINIS. District Attorney Dinis, surrounded by the media, makes a point on the courthouse steps during the inquest. His decision not to bring charges of manslaughter or negligent homicide, and instruction of a subsequent grand jury that there was no basis for charging Kennedy, made him a deeply polarizing figure during the investigation. (Photograph by Edith Blake.)

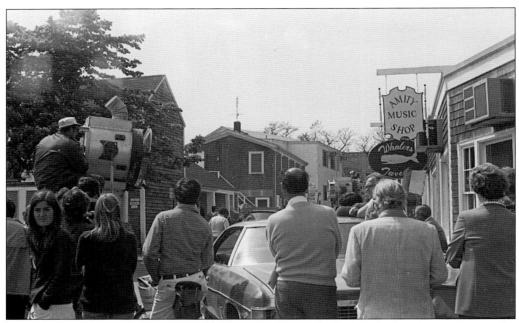

JAWS: EDGARTOWN BECOMES AMITY. The location filming for *Jaws* took place at sites all over the Vineyard in the spring and summer of 1974, but the on-screen story always returned to Edgartown, which played the film's fictional setting of Amity. Signs on the town hall, deli, and other businesses reflected the new name, star Richard Dreyfus examined a shark on a waterfront pier, and the *On Time* had a memorable cameo making what was—to Vineyarders—an obviously circular voyage in the channel between Edgartown and Chappaquiddick. The film famously makes a hash of island geography but, except when Chief Brody marches the wrong way up two one-way streets in succession, Amity feels like a real, coherent place. (Both photographs by Edith Blake.)

JAWS ON LOCATION. Hollywood's invasion of the Vineyard gave people from Edgartown and across the island a chance to be, however fleetingly, in the movies. In the panic scenes filmed on State Beach, for example, the carefree summer crowd frolicking in the water and then swimming ashore consisted of onlookers recruited en masse by an assistant director with a megaphone. This and other, smaller scenes offered a rare opportunity to see inside what was then an exotic and unfamiliar world where even mechanical sharks had makeup artists. Released in the summer of 1975, the finished film gave millions of moviegoers an extended look at the Vineyard and, specifically, at Edgartown—a world that was, at the time, as unfamiliar to most Americans as the inner workings of a movie set. (Both photographs by Edith Blake.)

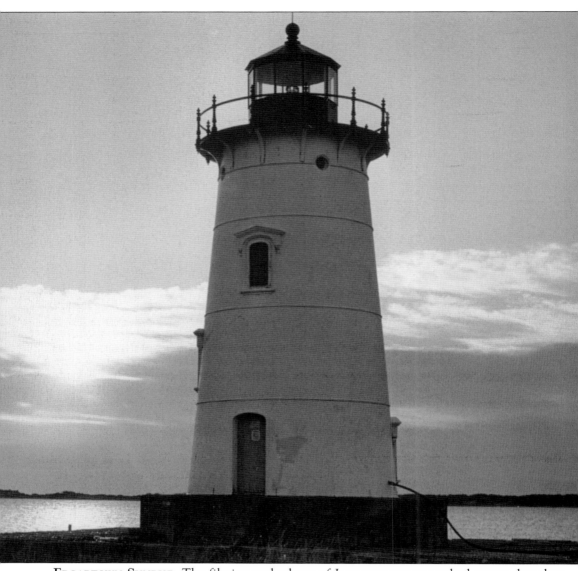

EDGARTOWN SUNRISE. The filming and release of *Jaws* were not watershed events, but they completed a process of discovery that began with derbies and regattas and continued with the Chappaquiddick incident. *Jaws* marked the beginning of a new day in Edgartown history, one where even first-time visitors felt as though they were stepping onto familiar ground.

EMBRACING THE SEASON. The changes that shaped Edgartown in the decades after *Jaws* extended those already begun and took place within a familiar framework established decades before. Main Street businesses became increasingly oriented toward the needs of tourists, year-round businesses moved to the outskirts of town, and the tourist season expanded to include the months from Columbus Day to Christmas. Having embraced, for better or worse, the annual influx of seasonal visitors, Edgartown worked to expand and refine its appeal to them. Memories of its rich and varied past were integral to that appeal, and—it seems likely—always will be. (Photograph by Teresa Kruszewski.)

BIBLIOGRAPHY

Banks, Charles E. *The History of Martha's Vineyard, Massachusetts.* Boston, MA: George H. Dean, 1911 (vols. 1 and 2); Edgartown, MA: Dukes County Historical Society, 1925 (vol. 3).

Blake, Edith. *On Location . . . on Martha's Vineyard: The Filming of the Movie* Jaws. Orleans, MA: Lower Cape Press, 1975.

Brown, George E., E. Michael Johnson, Mark Mulvany, and Tim George. *As We Were: The Edgartown Yacht Club, 1905–2005.* Edgartown, MA: Edgartown Yacht Club, 2005.

The Dukes County Intelligencer journal. Edgartown, MA: Martha's Vineyard Museum, 1959–present.

Dunlop, Tom, and Alison Shaw. *The Chappy Ferry Book: Back and Forth between Two Worlds, 527 Feet Apart.* Tisbury, MA: Vineyard Stories Press, 2012.

Hough, Henry Beetle. *Country Editor.* Garden City, NY: Doubleday, 1940.

———. *Martha's Vineyard: Summer Resort, 1835–1935.* Rutland, VT: Tuttle Publishing, 1936.

Kildegaard, Nis, and Alison Shaw. *Harbor View: The Hotel That Saved a Town.* Tisbury, MA: Vineyard Stories Press, 2014.

Lange, James E.T., and Katherine DeWitt. *Chappaquiddick: The Real Story.* New York, NY: St. Martin's Press, 1994.

Méras, Phyllis. *Country Editor: Henry Beetle Hough and the Vineyard Gazette.* Bennington, VT: Images from the Past, 2006.

Page, Herman. *Rails Across Martha's Vineyard: Narrow Gauge Steam and Trolley Lines.* David City, NE: South Platte Press, 2009.

Potter, Hatsy R. *Chappaquiddick: That Sometimes Separated but Never Equaled Island.* Rev. ed. Edgartown, MA: Chappaquiddick Island Association, 2008.

Railton, Arthur R. *The Story of Martha's Vineyard: How We Got to Where We Are.* Edgartown, MA: Martha's Vineyard Historical Society, 2006.

———. *Walking Tour of Historic Edgartown.* Edgartown, MA: Dukes County Historical Society, 1986.

About the
Martha's Vineyard Museum

The Martha's Vineyard Museum is dedicated to preserving and interpreting the history and culture of Martha's Vineyard. Its extensive collections of artifacts, documents, images, and stories form the basis of exhibits, programs, and publications designed to enable all people to discover, explore, and strengthen their connections to this island and its diverse heritage.

Founded in 1922 as the Dukes County Historical Society and incorporated in 1923, the organization acquired Edgartown's historic Thomas Cooke House (1740) as its headquarters in 1930. Additional land and buildings were added to its Edgartown campus in subsequent years, including a brick tower built in 1952 to house the 1856 first-order Fresnel lens from the Gay Head Light. The organization officially became the Martha's Vineyard Historical Society in 1996 and the Martha's Vineyard Museum—a name that better reflected its mission and extensive collections—in 2006.

The museum moved to a new headquarters, the 1895 US Marine Hospital overlooking Vineyard Haven Harbor, in 2018. Open year-round, it presents permanent and temporary exhibits on a wide range of Vineyard-related topics with a particular emphasis on seeking out and telling previously untold stories. The museum's extensive research library is available during business hours to any interested member of the public; the education department provides learning opportunities to thousands of individuals, from preschoolers to senior citizens, each year.

The museum continues to oversee the Thomas Cooke House in Edgartown and to act as steward of the Edgartown and East Chop Lighthouses. All three properties are staffed by museum volunteers and are open to the public from mid-June to mid-October.

More information about the museum's history, collections, exhibitions, and programs is available on its website, www.mvmuseum.org.

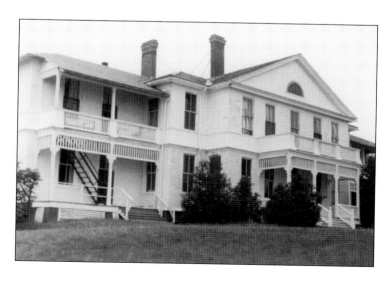

Discover Thousands of Local History Books
Featuring Millions of Vintage Images

Arcadia Publishing, the leading local history publisher in the United States, is committed to making history accessible and meaningful through publishing books that celebrate and preserve the heritage of America's people and places.

Find more books like this at
www.arcadiapublishing.com

Search for your hometown history, your old stomping grounds, and even your favorite sports team.